THE HISTORY AND TECHNIQUES
OF THE GREAT MASTERS

GAUGUIN

THE HISTORY AND TECHNIQUES
OF THE GREAT MASTERS

GAUGUIN

Linda Bolton

CHARTWELL
BOOKS, INC.

A QUARTO BOOK

Published by Chartwell Books
A Division of Book Sales, Inc.
110 Enterprise Avenue
Secaucus, New Jersey 07094

ISBN 1-55521-213-1

This book was designed and produced by
Quarto Publishing plc
The Old Brewery, 6 Blundell Street
London N7 9BH

Senior Editor Polly Powell
Art Editor Vincent Murphy

Project Editor Hazel Harrison
Designer Terry Smith
Picture Researcher Celestine Dars

Art Director Moira Clinch
Editorial Director Carolyn King

Many thanks to Bob Cocker and Paul Swain

Typeset by QV Typesetting Ltd

Manufactured in Hong Kong by Regent
Publishing Services Limited
Printed in Hong Kong by Leefung-Asco
Printers Ltd

CONTENTS

THE PAINTINGS

INTRODUCTION

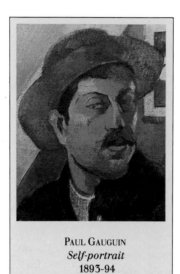

PAUL GAUGUIN
Self-portrait
1893-94
Musée d'Orsay, Paris

"I am a great artist and I know it," wrote Gauguin from Tahiti in 1892. "It is because I am, that I have endured such suffering." The remark is a testament both to the integrity of his artistic vision and to his "monstrous egotism." Gauguin never doubted his talent, attributing lack of financial success to the philistinism of the picture-buying market, or the corruption of dealers living off the backs of artists. "I feel I am right about art," he wrote in the year of his death, "in any case I will have done my duty, and there will always remain the memory of an artist who has set painting free."

Gauguin was always in search of an unspoilt haven where he could paint and live simply and cheaply. It was an elusive quest for a primitive idyll, and drove him ever further from western civilization — from Martinique to Tahiti, from Tahiti to the Marquesas Islands. But he was to find French colonialism had already made inroads into virgin territory like "decrepitude staring at the new flowering, the virtue of the law breathing impurely upon the native but pure unashamedness of trust and faith." Gauguin "saw with grief this cloud of smoke [and] felt ashamed of [his] race."

Illness, lack of funds and bureaucracy made life in Tahiti a nightmare, yet Gauguin was not tempted to abandon South Sea island life for an offer from a Paris dealer to receive a "modest but fixed income" for paintings produced at will. As Degas remarked, "Gauguin is the thin wolf without the collar (that is — he prefers liberty with starvation to servitude with abundance)." Gauguin's "haughty nobility, obviously innate," was, as his friend Charles Morice noted, "a simplicity that bordered on triviality ... aristocracy permeated by the proletariat." It was an image Gauguin approved. He saw his own origins as noble and exotic — "on my mother's side I descended from a Borgia of Aragon, Viceroy of Peru."

Gauguin ascribed immense importance to his Peruvian forebears, even though these connections were tenuous, deriving from a liaison between a young French woman, Thérèse Laisnay, who fled to Spain during the Revolution, and a noble Spanish colonel of Dragoons, Don Mariano de Tristan y Moscoso. This produced Flora Tristan, Gauguin's maternal grandmother. The Tristan Moscoso family had settled early in Peru, and Gauguin fancied that their blood had mingled itself with that of the ancient Incas. In adult life he referred to himself as a "Peruvian savage" and inscribed the frame of one of his works "a gift from Tristan de Moscoso" (see page 22).

Gauguin's Peruvian association encouraged him to consider himself as something of a "noble savage." It also suggested a hereditary urge driving him to follow his destiny in a way his ancestors had, and perhaps mitigated any sense of guilt he may have later felt in rejecting everything for his art. Gauguin revered his maternal grandmother, Flora Tristan, "a socialist-anarchist blue stocking," as he himself styled her, and kept her writings by him until his death. His career parallels that of his mother: having abandoned a spouse to follow her own star, "she spent her whole fortune," Gauguin tells us, "on the workers' cause, traveling ceaselessly." Although her pursuit, unlike Gauguin's own, was philanthropic, he had before him the example of one who had abandoned all material wealth for a cause, which was the way he chose to see his art.

Gauguin was born in Paris in 1848, a year which saw revolutionary activity throughout Europe. Disillusioned with the Second Empire of Louis Napoleon, Gauguin's republican father, Clovis, a political journalist, decided to set out for Lima in Peru, where his wife's great uncle and family lived, intending to start a newspaper. On the journey he collapsed and died of a ruptured blood vessel. His widow Aline traveled on to Lima with her two young children Marie and Paul, and on arrival good fortune attended her, for not only was her great uncle Don Pio a member of the Lima aristocracy (his son was President for some years) but the family was large and welcoming.

The four years Gauguin spent in Lima were never forgotten: "I still see our street with the chickens pecking in the refuse," he wrote in the last years of his life. It was a world of splendor and terror — of shock awakenings by madmen or earthquakes, remembered clearly by Gauguin half a century later. The Lima period ended abruptly with a return to France to settle an inheritance from his paternal grandfather. Life in Orléans after the colorful city of Lima "where it never rained" was gray and unwelcoming. Gauguin saw it as the end of a golden age — "although never in actual poverty, from this time on, our life was extremely simple." It is part of the Gauguin fable that his early memories of his Peruvian days bred a nostalgia for exotic lands and a yearning to seek out undiscovered countries where he could live the life of a "primitive savage." His wanderlust found an outlet in 1865 when at the age of seventeen he joined the merchant navy, sailing to the distant shores of the Atlantic and Pacific oceans. Doubtless it stirred memories of his childhood.

Although he did not begin to paint until his mid-twenties, Gauguin evidently responded to pictures from an early age. Sometime around his tenth year, "beguiled" by a picture, he took it into his head to run away to the forest of Bondy with a handkerchief full of sand at the end of a stick which he carried over his shoulder." His introduction to the world of art came from a family friend, Gustave Arosa, who became his guardian on the death of Gauguin's mother in 1867. An important art patron and collector of avant-garde works, Arosa was also responsible for getting Gauguin his position with the banking firm of Bertin in Paris. Here he met Emil Schuffenecker,

PAUL GAUGUIN
Les Lavandières
1886, Musée d'Orsay, Paris

This work shows the Impressionist style Gauguin inherited from Pissarro. It is an example of an intermediate technique characterized by the use of long, thin, curved strokes of prismatic color. This technique is different both from his earlier use of short, wide dabs of pigment in the same tonal range, and from his later use of flat areas of unbroken color and dark outline.

who was to become a loyal and lifelong friend, and who persuaded Gauguin to paint with him on Sundays.

Although he received no formal training, Gauguin's earliest works are remarkably accomplished (a term he would later consider pejorative). He had an eye for the masterpieces of the new Impressionist style; for the yet-to-be fashionable pictures in the collections of "Père" Tanguy and the dealer Durand-Ruel. By 1880 he owned works by Daumier, Manet, Renoir, Monet, Cézanne, Pissarro, Sisley, Guillamin and Jongkind, so that "if his brush hadn't led him, his fame would have rested on his collection."

Through Arosa Gauguin met Camille Pissarro, whose impact on him at the beginning of his career was great, and led to an increasing absorption in painting and

involvement with other members of the Impressionist circle. He exhibited with them in 1879, 1880, 1881, and 1882 — against the wishes of Monet and Renoir. Gauguin's landscapes, whose style had previously been conditioned by those of Corot, which he had seen in Arosa's collection, took on an Impressionist flavour under the influence of Pissarro. His immersion in the works of the avant-garde painters of the day provided him with the means of "discovering" the "secret" of expressing nature adopted by those progressive artists. This, combined with occasional visits to the less formally rigid *ateliers* in order to improve his life drawing, formed the basis of Gauguin's art training. His ideas on painting were developing faster than his means of conveying them.

The pursuit of art

In 1873 he met and married a young Danish girl, Mette Sophie Gad. By 1883 they had had five children, and were living comfortably on Gauguin's salary as a banker. However, there was a serious financial slump that year, and Gauguin abandoned his position at the banking firm with the intention of providing for his family by the sale of his paintings. Unable to make a living in Paris, he

CAMILLE PISSARRO
Diligence at Louveciennes
1870, Musée d'Orsay, Paris

Pissarro was the greatest single influence on the work of Gauguin, and his revolutionary technique earned him

Gauguin's respect in the first years of their acquaintance. Later, however, Gauguin scorned him. "You see what has happened to Pissarro... always wanting to be in the vanguard...he has lost every atom of personality."

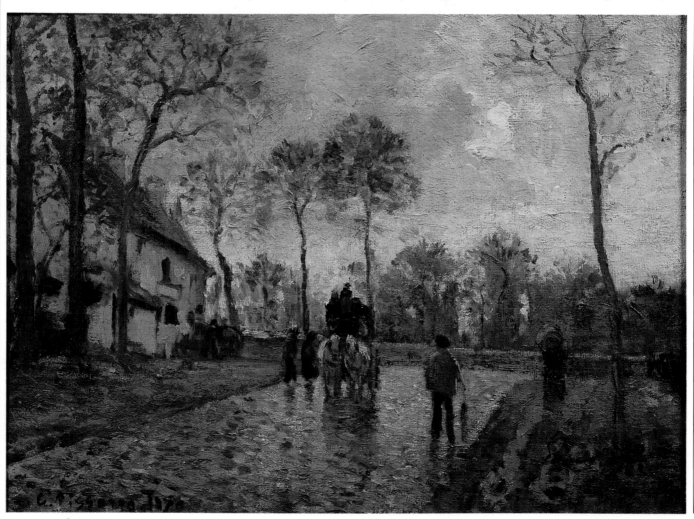

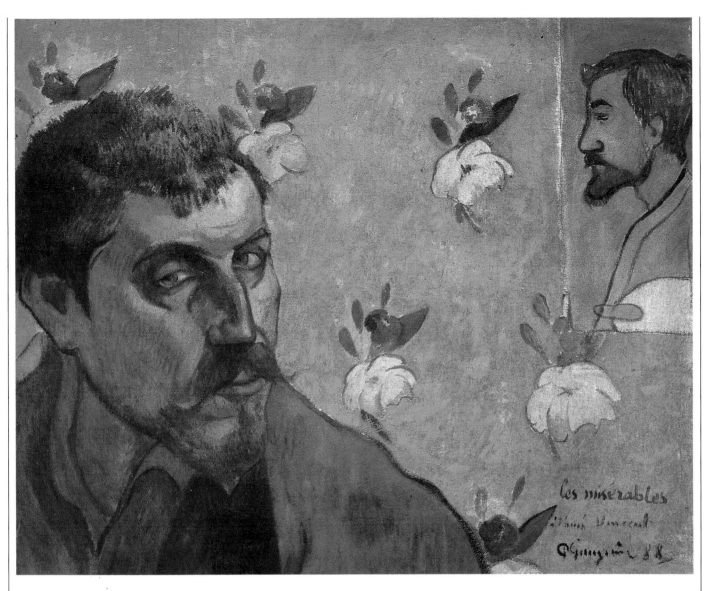

removed his family to Rouen, where Pissarro was working, and the cost of living cheap, and then to Copenhagen, where he tried unsuccessfully to make ends meet by selling waterproof canvas. Humiliations for Gauguin and his wife led to misunderstandings which were never resolved, and bred in Gauguin a hatred of the Danes, and in his wife an equal hatred for painting, as she discovered her best table linen used for canvas and her finest petticoat torn up for paint rags. Their lengthy correspondence of mutual reproach chronicles a constant demand for cash on her part and a statement of direst poverty on his, peppered with remarks from him on the relative ease and comfort of her life among her family and friends in comparison with his. However, although they were never to live together after 1885, Gauguin considered himself bound to her and their children, even occasionally thinking wistfully of their reunion as a family, and he also wrote to her about his painting.

Gauguin returned to Paris with his favorite son Clovis, and for a time lived in extreme poverty, eventu-

PAUL GAUGIUN
Les Misérables
1888, Van Gogh Museum, Amsterdam

As Gauguin explained to Van Gogh, the title of this self-portrait, was a reference to the "tormented hero" of Victor Hugo's novel. Gauguin saw in his own head "the mask of a... powerful ruffian... who has a certain nobility and inner kindness."

ally being reduced to bill-sticking to provide enough funds to nurse the boy through smallpox. His pursuit of art to the exclusion of almost every physical comfort; his rejection of family, career and physical well-being for a life of hardship which resulted in an early death from malnutrition exacerbated by syphilis, has become legendary, with Gauguin the exemplar of the heroic artists struggling against all odds in order to communicate his personal vision. As he shook off his domestic commitments Gauguin felt the heroic anima of the "Peruvian savage" assert itself.

The Brittany period
In 1886, having exhibited nineteen paintings in the

eighth and last Impressionist Exhibition, and having placed Clovis in a boarding school, Gauguin moved to Pont-Aven in Brittany. Free from the burden of fatherhood he could at last develop his art in the hard, primeval land to which the "barbarian" in him responded. "I love Brittany," he wrote to Schuffenecker in March 1888, during his second stay there, "I find there the savage, the primitive. When my clogs ring out on the granite soil I hear the dull, muted, powerful tone which I seek in my painting."

Brittany was the turning point in Gauguin's artistic development. Here, away from the influence of Paris and the Impressionists, he found the technical means to express the vision he had long held, intensified by a spell in Martinique in 1887, where he went in search of a tropical haven. He began to move away from naturalism toward suggestion, achieved by symbolic use of line, color and allusion to convey the expressive mood of his response to the subject. He was concerned now with the artist's interpretation of nature rather than with any virtuosity of technique in rendering external appearances.

Gauguin's realization of his personal means of expression reflects the desire of several artists to find new ways of interpreting nature. The avant-garde of the 1880s did not represent a cohesive art movement. The full flower of Impressionism had blossomed. Seurat and Signac, whom Gauguin described as "those petty chemical persons who pile up little dots" were extending an Impressionist concern with light into a more scientific formula. In French literary circles positivism and belief in the supremacy of the science-ideal engendered a reaction against naturalism, and the creation of a new literature based on imagination and feeling was beginning to

PAUL CÉZANNE
Still Life with Open Drawer
Private collection

Gauguin was given a still life by Cézanne and refused to part with it through the years of poverty, describing it as "a pearl...the apple of my eye." He jokingly urged Pissarro to drug Cézanne and make him talk in his sleep in order to discover his "secret," a joke which earned him Cézanne's dislike.

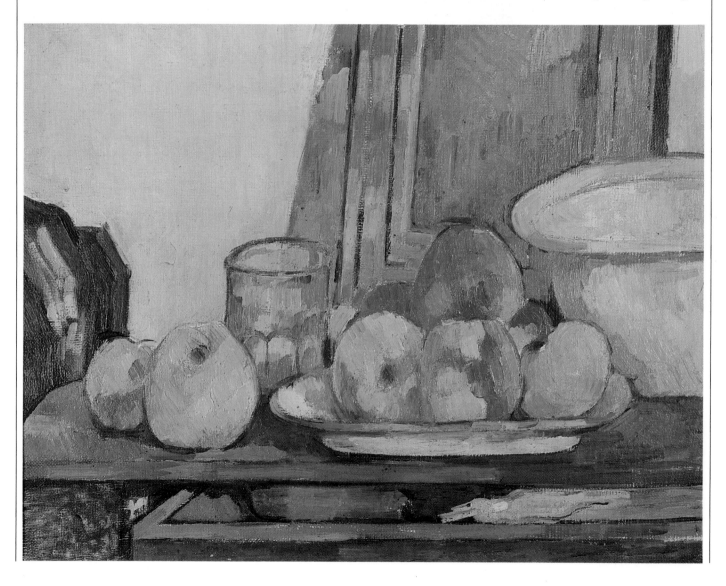

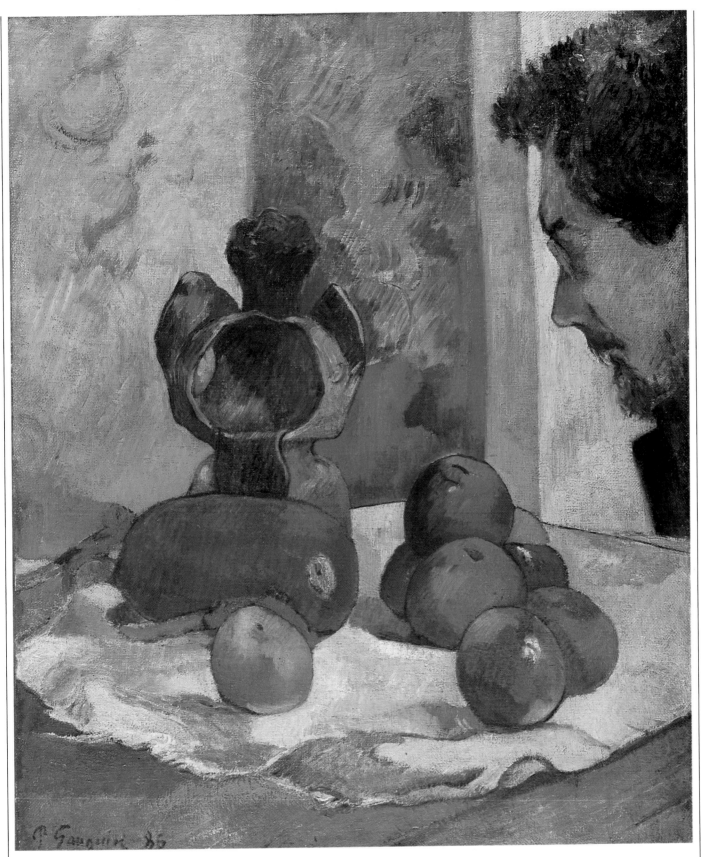

PAUL GAUGUIN
*Still Life with Portrait of
Charles Laval*
1886, Private collection

On starting a new canvas
Gauguin would say "Let's
make a Cézanne!" The debt to
Cézanne is evident here in the
brushwork and the modeling
of the fruit, but the cropping

of Laval's head is a motif
directly borrowed from Degas.
The remarkable piece of
sculpture is one of a number
Gauguin made with Chapelet
during 1886.

prevail against the dominance of the "sordid realism" of Emile Zola and the de Goncourt brothers. This anti-naturalism had earlier been espoused by the painter Eugène Delacroix and the poet and critic Charles Baudelaire, and now, informed by the literary debates of the 1880s, Gauguin found himself endorsing this position and cursing western society which "has fallen into the abominable error of naturalism."

The dominance of literary symbolism found a responsive chord in both Gauguin and Emile Bernard, a young artist he got to know during 1888 in Pont Aven. Both were moving toward the same resolution — the evolution of a style of painting where "Ideas dominate technique," and the attempt to create a visual poem through the symbolic use of line and color became Gauguin's principal aim. The strength of his taciturn but dominant personality attracted a number of the artists in the Pont-Aven circle, where he assumed the leading role. It was a source of mental anguish to Bernard that the creation of *synthétisme* was attributed to Gauguin just because of this dominance, when Bernard had "proof" of having painted works in the style before Gauguin's. However, Gauguin's remarkably inventive ceramics executed in 1887 — the year before his association with Bernard — show that he was already moving in a similar direction to that of the younger man.

PAUL SERUSIER
The Talisman
1888, Musée d'Orsay, Paris

Serusier painted this tiny panel in the Bois d'Amour outside Pont-Aven under the direction of Gauguin, whom he greatly admired. In Paris it became, as the Symbolist painter Maurice Denis claimed, the key image for the evolution of the second generation of Symbolist artists.

PIERRE PUVIS DE CHAVANNES
The Poor Fisherman
1884, Musée d'Orsay, Paris

Puvis' primitivism and depiction of a simple lifestyle inevitably led to comparisons between his work and

Gauguin's. Irritated by the suggestion that he should make his symbolism as clear as Puvis', Gauguin responded, "Puvis explains his ideas but does not paint them," adding, "he is the Greek while I am the savage."

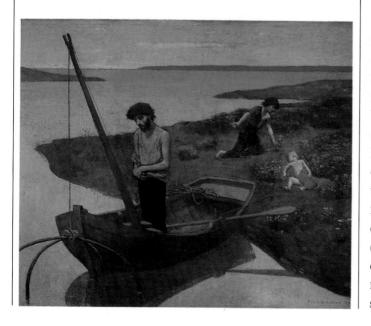

The word synthetism was a catchword of the age, used to convey a sense of "artistic unity, harmonious composition, internal unity of conception, the understanding and the coherence of forms and colors." Bernard's search for a pictorial expression of literary symbolism resulted in the reduction of subject matter to its essentials; forms were simply expressed by means of a few lines; color was applied evenly and flatly, intensified by a dark outline which separated one color from another like a piece of stained glass or cloisonné enamel. Bernard's work was the final trigger in Gauguin's process of working out his artistic credo. "Art is an abstraction," he wrote to Schuffenecker in 1888. "Extract from nature by dreaming in front of it, and think more of the creation which will result." His *Vision after the Sermon* (see page 23), the first product of the ideas which had crystallized over that summer, shows his individual response to the piety of the Bretons, and presents a personal, imaginary, non-naturalist image of a mental state.

GAUGUIN'S PAINTING METHODS

In this detail of Nevermore *we see the deep blue outline Gauguin frequently used to strengthen and define his forms.*

Although Gauguin's paintings give the impression of flat color, there are actually considerable variations in each individual area.

In this detail from Where Do We Come From? *the texture of the rough hessian canvas can be seen clearly. Often the canvas was left unprimed.*

Gauguin's painting technique was quite different from both that of the Impressionists, who applied their colors in small, opaque dabs, and that of Van Gogh, who used thick impastos and bold, expressionistic brushstrokes. Gauguin's paintings in the main are characterized by broad areas of color, relatively flat but nevertheless containing subtle variations of hue that give them a rich glow. He often added wax to his paints to give them extra smoothness and flow, and the paint is seldom thick, being thinnest at the edges of forms, where Prussian blue or earth red is often used to outline and strengthen the shapes. Sometimes parts of backgrounds were applied with a palette knife and then overlaid with thin, translucent paint put on with a brush.

In his Tahiti period he often painted on unprimed hessian, or sackcloth, and in many of the paintings done at the time the weave of the rough fabric is clearly visible through the paint. This was partly a consequence of his poverty, as was the thinness of the paint in some of his works, but he had begun to experiment with coarse canvas with Van Gogh in 1888, and found that the hairy surface of sackcloth enhanced the "barbaric" qualities he so much admired.

We know a good deal about his methods and the colors he used from his own copious writings and the following letter to the picture dealer Ambrose Vollard, written from La Dominique in March 1902, gives us an idea of the palette he favored at the time as well as of his financial problems.

Gauguin's palette in his Tahiti period probably consisted of the colors shown here plus lead white.

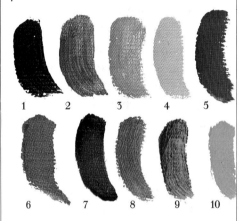

1 Black; 2 Raw sienna; 3 Yellow ocher; 4 Cadmium yellow; 5 Red earth (red ocher); 6 Vermilion; 7 Prussian blue; 8 Cobalt blue or ultramarine; 9 Viridian; 10 Emerald green.

Dear M. Vollard,
 I have opened your box.
Canvas and glue — perfect
Japanese paper — perfect
But the colours!!!...What do you expect me to do with 6 tubes of white and terre verte, which I seldom use? I have only one small tube of carmine lake left. So you must send me immediately:
20 tubes of white
4 large tubes carmine lake
2 large tubes light vermilion
10 large tubes emerald green (Veronese)
5 large tubes yellow ochre
2 large tubes Ochre de Ru
2 large tubes red ochre
Powdered colour — Charron blue, ½ litre, large tube
... Now that I am in the mood for work I shall simply devour paints. So buy Lefranc's decorators' colours, they cost a third as much, especially as you get a dealer's discount, and they are much better.
 Paul Gauguin

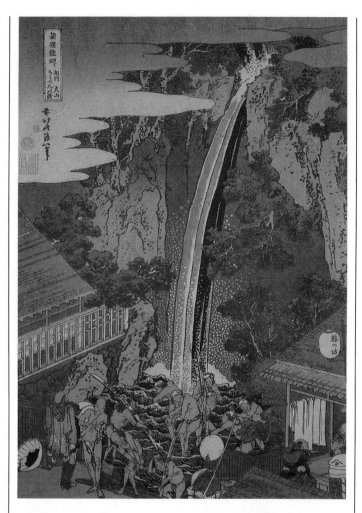

HOKUSAI
Waterfall of Roben
1827, Victoria and Albert
Museum, London

Gauguin collected Japanese
sketches and Hokusai prints.
Like the Impressionists, all of

whom were influenced by
Japanese prints, he admired
the features of this art form
which cropped figures,
flattened perspectives, used
flat areas of unbroken color
and dark outline, omitted
shadow and simplified form.

The Tahiti period

But although Brittany was certainly the focus for the fermentation of Gauguin's art theory, Tahiti is the place most readily associated with his work. In Tahiti he continued to pursue his aim: "There are transformations every year, it is true" he wrote to his wife in 1892, "but they follow each other in the same direction." His iconography of the Tahiti period incorporates the solid, golden-skinned natives of the islands, with poses borrowed from both traditional western and eastern sources. He borrowed from the Parthenon frieze and pediment; from Javanese and Egyptian temple friezes; from Puvis de Chavannes and Manet; and from the Indian Buddha in his attempt to consolidate and reinterpret his personal symbolism. The harshness of the Brittany works, characterized by dark outlines and sharply angled perspectives, was now replaced by a gentler, more flattened, frieze-

like, rhythmic arrangement, as seen in paintings like *The Market* (see page 41) and, *Where do we come from?* (see page 49). Symbolism has become more personal, the works more mysterious. His color range too, is more rich and varied, the jarring rust and yellow contrasts of *The Yellow Christ* (see page 31) being replaced by a light, bright palette, as in *The Market*, or by a rich sonorousness as in *Nevermore* (see page 45).

Gauguin had arrived a century too late to find in Tahiti an undiscovered country. Horrified at the inroads made by missionaries, who had inculcated ideas of sin in the islanders, and by French government officials, who had imposed bureaucracy on their simple way of life, Gauguin was active in urging the natives to resist both. In 1899 he even ceased painting to write about the injustices and corruption he had witnessed on the island. He viewed with horror the French women "dowdy from head to foot, with their superannuated finery, vulgar hips, tumble-down corsets, imitation jewelry, elbows that threaten you or look like sausages," regarding them as "enough to spoil any holiday in this country. But they are white — and their stomachs stick out!" He kept completely away from colonial life, preferring to dress and live "native," and to take as mistresses young Tahitian girls. The young native woman, he said, "even if she wanted to, could not be dowdy or ridiculous, for she has within her that sense of decorative beauty." This was something he had come to admire in the Tahitian's art.

The inner vision

For Gauguin, the artist was a heroic figure, possessed by a desire to reject all that was not connected with his calling. The idea of the artist as a man of inner vision is an important element in any subsequent evaluation of an artist for whom technique was to become subordinate to message. Gauguin saw the sublimity of a work of art as quite unconnected with the kind of manual dexterity admired by the Academicians. He scorned Academy-trained painters, like Bouguereau, who did no more than render the exterior of an object naturalistically, and stressed the artist's sacramental role in giving outward form to the Idea. The discrepancy between the length of time needed for the execution of a work and the inevitable fluctuation in intensity of feeling troubled him: "Where does the execution of a painting come from and where does it end?" The two, he felt, ought to be simultaneous; the result of "that moment, when the most intense emotions are fused in the depths of one's being, when they burst forth and when thought comes up like lava from a volcano ... like an explosion." He believed almost in the pre-existence of a work of art:

"The work is created suddenly, brutally if you like, and is not its appearance great, almost super-human?"

Gauguin realized the quality of his legacy to later painters, remarking, "The public owes me nothing since my pictorial oeuvre is only relatively good, but the painters of today who are benefiting from this newborn freedom do owe me something." By his own admission his technique was only relatively good, but his "inventive originality" was important for the subsequent development of twentieth-century art. He was in the vanguard of those who rejected the naturalist tradition of treating only the exterior world, and regarded the "mysterious center of thought," man's inner response to nature, of paramount importance. His championing of the so-called primitive forms of art, especially that of the South Seas, influenced the vogue for Primitivism in the first two decades of the twentieth century, and his rejection of western materialism in favor of a primitive idyll made a great impact on subsequent generations of artists.

PAUL GAUGUIN
La Plage du Pouldu
1889, Private collection

Gauguin saw in Japanese art the reflection of a simple and composed lifestyle. "The great error is in the Greek," he wrote, "we need to seek the clearest form." He preferred the flatness of Egyptian decorative art or the Japanese woodcut to the classical western tradition, and in this painting the Japanese influence is very evident.

CHRONOLOGY OF GAUGUIN'S LIFE

1848 June: Paul Gauguin born.

1849 Family sets sail for Lima, Peru.

1855-65 Family returns to France. Gauguin joins merchant navy in 1865.

1868-71 Military service in the French navy. Leaves navy in 1871. Gustave Arosa finds him work with the Parisian banker Bertin. Meets Emile Schuffenecker.

1873 Summer: Begins to paint under the tutelage of Arosa's painter daughter Marguerite. November: marries Mette Sophie Gad.

1874 First son Emile is born in August.

1876 *Landscape at Viroflay* accepted by the Salon. Begins to buy paintings.

1877 Meets Pissarro. Starts to collect Impressionist paintings. December: daughter Aline is born.

1879-82 Exhibits with the Impressionists. Two further sons born.

1883 Gives up job to devote himself to painting. December: Fourth son born.

1884 Moves with his family to Rouen..

1885 Joins his wife and family in Copenhagen. June: Returns to Paris with son Clovis.

1886 In desperate poverty. Puts Clovis in boarding school. Shows paintings in 8th and last Impressionist Exhibition. Spends June-November in Pont-Aven, Brittany. Breaks with Pissarro. Sees much of Degas. Meets Van Gogh.

1887 April: Sets off for Panama "to live like a savage." June: In Martinique. Becomes ill, works his passage back to Marseilles.

1888 February: Returns to Pont-Aven. October: Joins Van Gogh in Arles, returning to Paris in December.

Vision after the Sermon: Jacob Wrestling with the Angel

The Yellow Christ

Manao Tupapau: The Spirit of the Dead Keeps Watch

Ta Matete: The Market

1889 June: Exhibits with friends at the Café Volpini. Returns to Brittany.

1890 Working in Paris and Brittany. Close contact with Symbolists.

1891 Decides to leave for Tahiti. Has relationship with Juliette Huet, who later bears him a daughter. March: Goes to Copenhagen to bid his family farewell. Banquet held in his honour at the Café Voltaire, presided over by Mallarmé. April: Departs for Tahiti, arriving in May. August: In hospital, coughing blood.

1892 Begins to compile book about Tahitian folklore. Lives with thirteen-year-old Tehamana.

1893 August: Returns to France. Inherits a small legacy. Lives with Anna "the Javanese." Starts to write *Noa Noa*, an idealized account of primitive life in Tahiti.

1895 Suffering from syphilis, sells up and returns to Tahiti. Settles with fourteen-year-old Pahura.

1897 Ill and depressed, decides to commit suicide after painting his largest picture *Where Do We Come From?*

1898 January: Takes arsenic but fails to kill himself.

1901 Moves to the Marquesas. Settles with fourteen-year-old Vaeoho.

1902 Incites natives against colonial government. Vaeoho bears him a daughter. Starts writing his *Intimate Journals*.

1903 Accused by authorities of libel and stirring up anarchy. Sentenced to three months imprisonment. Appeals but dies on 8 May, aged fifty-five.

THE PAINTINGS

PONT D'IENA

1875

25½×36¾in/64.7×92cm

Oil on canvas

Louvre, Paris

Gauguin did not start to paint until he was twenty-five, when Marguerite, the painter daughter of his guardian Gustave Arosa, taught him the technique of oils in the summer of 1873. Inspired by Arosa's collection of contemporary work, and encouraged by Marguerite, Gauguin's interest in art received a further stimulus from his association with Emile Schuffenecker, who was also an employee of the banking firm of Bertin where Gauguin had worked since 1871. Schuffenecker urged Gauguin to join him on Sunday excursions to the outskirts of Paris to draw and paint, and also to accompany him on occasional evening visits to the Atelier Colarossi to draw from the life model.

Gauguin soon followed Arosa's example and began to amass his own collection of avant-garde paintings, initially the naturalistic but freely handled landscapes by artists such as Corot, Jongkind and Pissarro but later the more revolutionary work by the group of painters who came to be called the Impressionists. The basis of Gauguin's art training was thus the close study of actual works of art rather than a formal studio training, and so he did not feel the same need as other artists to rebel against academic teaching practices or the dominant artistic conventions of the day.

The Impressionists themselves rejected the traditional academic art theories insisted upon by the Salon, preferring to develop the freer painting technique of Delacroix, who had in turn been influenced by the color and freshness of the English landscape painters. Courbet, with his non-academic subject matter, and the outdoor (*plein air*) painters of the Barbizon school were also important influences in the new movement which sought to cut across fossilized tradition. Historical and religious themes, regarded by the Salon as the only proper ones for a serious artist, were now rejected in favor of landscapes or city scenes depicting modern life, and the traditional painting methods, of drawing from a model in the studio, preparing sketches, and then producing contour outlines to be "painted in" were replaced by a much more direct approach. The Impressionists preferred to work out of doors, attempting to catch the impression of a fleeting moment by means of bold dashes of prismatic color.

This painting, done after two years of self-tuition, resembles a Monet of the same date, both in the choice of subject matter and in the handling, particularly of the sky, which is similar to that in Monet's *Westminster Bridge* of 1871. The treatment of the water does not, however, reflect Monet's bold technique of applying dashes of unmixed color; the effect produced here is therefore calmer and more reminiscent of Pissarro's finely handled snow-scenes. The influence of Pissarro was remarked on by the novelist Huysmans, who described Gauguin's paintings exhibited at the Impressionist show as "dilutions of the still-hesitant works of Pissarro." Pissarro was to remain a major influence for over six years, and this work demonstrates how competently Gauguin had absorbed the ideas and techniques he had studied. Small dabs of the gray-violet range laid next to each other give a snow-laden feel to the sky, and snow-capped trees are realized with a few touches of the brush. Although Gauguin was never to acknowledge Pissarro as his master in the way Cézanne had, he learned much from this artist whom he was later to despise for always following artistic fashions to the detriment of his own personal vision.

It was also through Pissarro's influence that Gauguin was able to exhibit at the Impressionist Exhibitions, against the wishes of certain other members, and he became allied with the group until the development of his own artistic credo in the 1880s led him to reject the Impressionists' technique, which he came to disapprove of because it "dwelt too much on the outward form and not on the mysterious center of things."

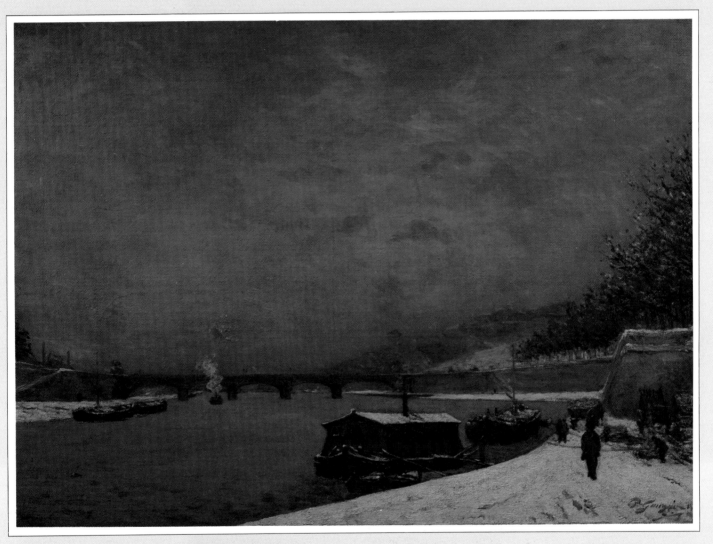

This early work is painted in the idiom of the Impressionists, whose first exhibition Gauguin had seen in 1874. The subject matter is an everday scene: a winter riverscape. Following established tradition, the horizon cuts across the lower third of the canvas, above which the remaining two-thirds of the painting is occupied by sky. The influence of Japanese prints was the principle source of Gauguin's later rejection of this technique; open sky is rarely apparent in his mature work, where perspective is to a large degree flattened. This painting shows how ably he had absorbed the technique and style of Pissarro and the Impressionists.

1

2

3

1 The sky is treated with dabs of green-blue, white, cream and pink. Color is less important than tone in this early work. It is reminiscent of Monet's treatment of the sky in his *Westminster Bridge*, although here the paint is not laid down in short brushstrokes of pure color but in dashes of pre-mixed pigment.

2 Unlike the treatment of the sky the river shows a much denser application of thick paint unbroken by brushwork or color harmonies. The effect of snow on the bank is created by dabs of color in the same tonal range, and the wall surface with a thinner application of monochromatic color.

3 The trees are realized with light, impressionistic touches of the brush, but color harmonies are not derived from the Impressionist selection of primaries but taken from a more naturalistic, less experimental tradition which uses the brown-green range, tipped with dashes of Naples yellow and white.

4 *Actual size detail* Highly reminiscent of Pissarro's snow-scenes, these figures are monochromatic and solid, not impressionistic either in color or technique. The effect of ridged snow is created by a thick application of mixed color in the cream, gray and pink tonal range.

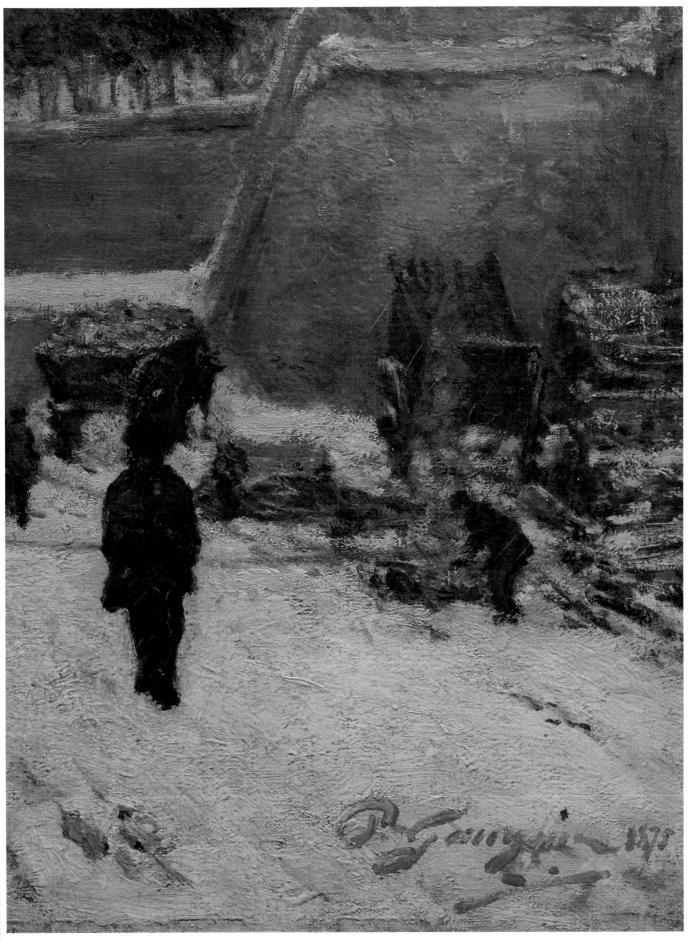

4 *Actual size detail*

VISION AFTER THE SERMON:
JACOB WRESTLING WITH THE ANGEL

1888
25½×36¾in/64.7×92cm
Oil on canvas
Jeu de Paume, Louvre, Paris

This work, Gauguin's first masterpiece, is a clear expression of his aims in painting, a crystallization of the ideas on art which he had developed in Pont-Aven that year. It represents not only Jacob's struggles, as seen in the minds of the pious Bretons, but also Gauguin's own struggle, his grappling with technique to convey his newly realized ideas.

Writing to Van Gogh in the same year, Gauguin said "I believe I have attained in these figures a great rustic and superstitious simplicity. It is all very severe ... To me in this painting the landscape and the struggle exist only in the imagination of these real people and the struggle in this landscape which is not real and which is out of proportion."

Although disdainful of the Catholic teaching he had received at school, Gauguin was impressed by the simple faith of the Breton women, whose traditional headdress and bearing reminded him of a religious order. It is not a religious picture so much as a painting of religious people, and more ambitiously, it attempts to show the strength of their faith. The scene was inspired by the piety of the peasant women, whose response to the sermon they have just heard evokes a vision of the struggle with evil.

The biblical scene is sited at the upper right of the canvas, separated from the praying group of women and priest in the foreground and righthand edge of the picture. The diagonal sweep of the apple tree, a pictorial device borrowed from Japanese art, divides the real from the visionary in both a literal and a symbolic way. The cropping of the foreground figures, the rejection of traditional perspective, the flattening of form, and the rejection of shadows also show the influence of Japanese prints, an influence which was felt by all those associated with Impressionism. Simplification of figures and flat unmodeled areas of bright color had already been practiced by Emile Bernard, twenty years Gauguin's junior, and had profoundly influenced Gauguin; both artists had been impressed by folk woodcuts and medieval stained-glass windows. A return to a simpler, cruder, more archaic style, both of life and of art, was what Gauguin now sought.

Stress on composition and form are not accidental in this painting, which was intended as a kind of demonstration of the essentials of a "synthetic" work of art, in which the effect was achieved by the internal unity of color, line, form and composition. The influence of Bernard is apparent in the use of unmixed colors applied in large areas and bounded by a blue-black line to increase their intensity. Bernard had been producing pictures of this sort before Gauguin's masterpiece, but Gauguin's own ceramics of the previous year show that both artists were moving in the same direction, needing to free themselves from the traditional western practice of naturalism in favor of a spiritual quest to discover the inner nature of the subject.

On the frame of his painting Gauguin wrote in blue letters, "a gift of Tristan de Moscoso," and offered it to the local church at Nizon, interested to learn the effect his Vision would produce on the congregation. However, having satisfied himself that the picture was not a hoax, the curé rejected it on the grounds that the parishioners would not understand it.

22

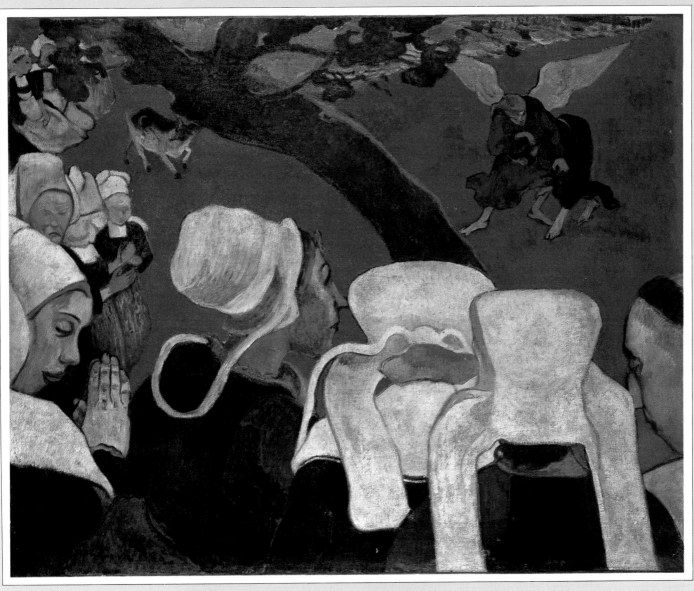

Unlike Gauguin's earlier work this painting depicts an imaginary setting. It represents a definite break from the Impressionists, with whom Gauguin had become increasingly dissatisfied because of their concern with the outward appearance of things. He was seeking a means of expressing abstract emotional qualities in his paintings, and here he is conveying his personal reaction to Breton piety. The assertiveness with which he seems to have embraced this newly found technique is reflected in the work. The composition is dramatically bisected by a strong diagonal, either side of which the imaginary and the actual are boldly realized.

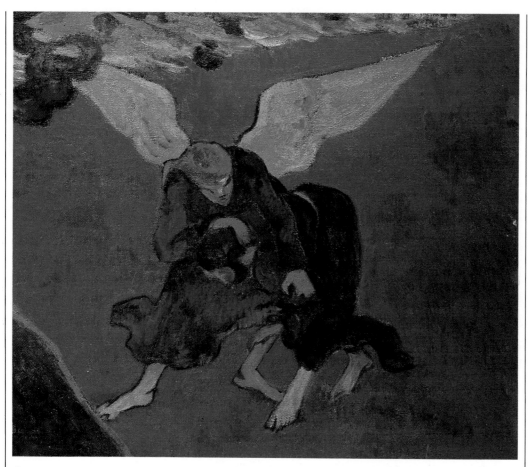

1

2

1 The figures of Jacob and the Angel are based on those of the Japanese artist Hokusai, whose art Gauguin greatly admired. Modeling has been replaced by the use of flat areas of color intensified by a dark outline.

2 The cropped profile of the priest is a feature borrowed from both Japanese art and Degas. The headdress and collars are treated as flat white areas, shadowed with pale blue, brushed on in vertical strokes. They are seen almost as abstract forms rather than representations of people.

3 *Actual size detail* This profile of the praying woman shows features borrowed from Japanese prints, folk art, and medieval stained-glass windows. The face is barely modeled, and is boldly highlighted in white. The lower lip, formed with a crimson stroke, takes up the background color. Features, headdress, and hands are outlined in Prussian blue.

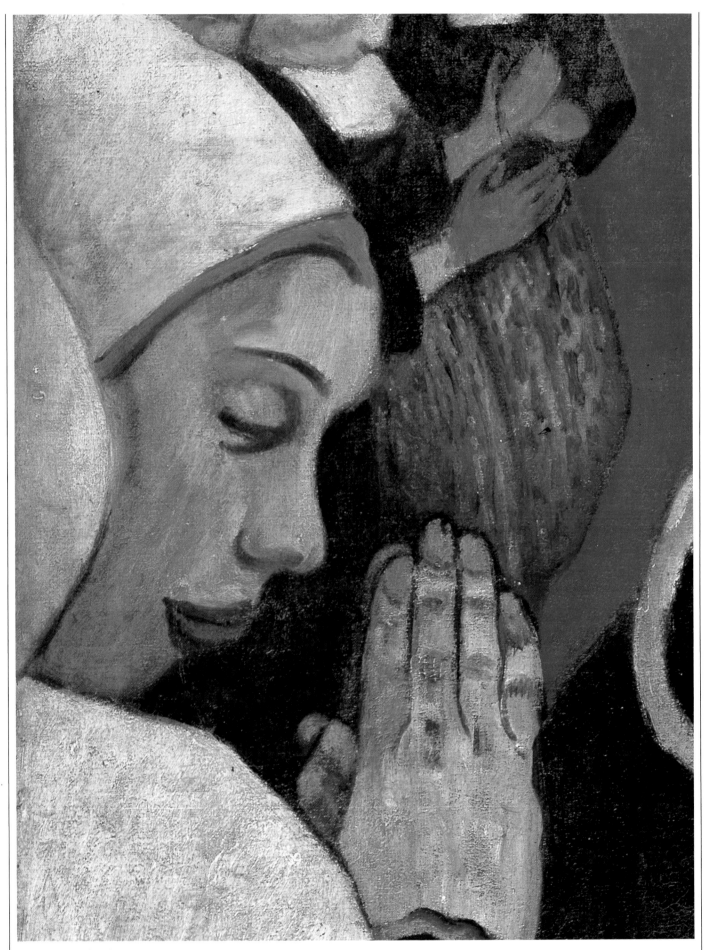

3 *Actual size detail*

VAN GOGH PAINTING SUNFLOWERS

1888

29¼×36¾in/73×92cm

Oil on canvas

Van Gogh Museum, Amsterdam

Following Van Gogh's invitation to join him at his studio in Arles, Gauguin arrived from Brittany in October 1888. The "primitive" Gauguin found Vincent's beloved town in the south too "pretty and paltry," and made no attempt to conceal his feelings. Fifteen years later Gauguin wrote of the period the two spent together:

"For a long time I have wanted to write about Van Gogh ... in order to correct an error which has been going around in certain circles." The error referred to was, of course, Gauguin's contributory role in the madness and eventual death of Van Gogh himself and then of his brother Theo. "It so happens," acknowledged Gauguin, "that several men who have been a good deal in my company and in the habit of discussing things with me have gone mad. This was true of the Van Gogh brothers, and certain malicious persons have childishly attributed their madness to me." While Gauguin cannot be blamed for the instability of the Van Goghs — a sister who never met Gauguin also went mad — his visit certainly caused a great strain.

Having formed his own ideas on painting, and assumed the role of "Master" at Pont-Aven, Gauguin "undertook the task of enlightening" Vincent. The relationship was seen by both as that of master and pupil. "Van Gogh, without losing an ounce of his originality, learned a fruitful lesson from me. And every day he thanked me for it."

The lesson lay in instructing Van Gogh not to paint too much after nature but from the imagination. Gauguin also discouraged "all this work in complementary colors [which] accomplished nothing but the mildest of incomplete and monotonous harmonies. The sound of the trumpet was missing in them." He was also critical of Vincent's untidiness: "I found a disorder that shocked me. His color-box could hardly contain all those tubes, crowded together and never closed."

Gauguin wrote of his painting, "The idea occurred to me to do his portrait while he was painting the still-life he loved so much ... when the portrait was finished he said to me 'It is I, but I gone mad'." The remark was a prelude to the recurring bouts of madness Vincent experienced. "That very evening" wrote Gauguin, "we went to the café. Suddenly he flung the glass and its contents at my head. I avoided the blow and, taking him bodily in my arms left the café." The following evening while taking a walk Gauguin related the events which indicate the intensity of Van Gogh's unbalanced state of mind: "I ... turned as Vincent rushed toward me, an open razor in his hand. My look at that moment must have had great power in it, for he stopped." Vincent's subsequent action with the razor, the incident of the severed ear, washed and consigned to a prostitute to give to Gauguin as a souvenir, is well known. It ended the relationship as far as Gauguin was concerned, although he depended on the efforts of Theo, Vincent's younger brother the picture dealer, for the sale of his paintings. Vincent's suicide in 1892 brought on Theo's despair and death the following year, which dashed Gauguin's immediate financial hopes.

The portrait shows a deliberate flattening of form — Gauguin found modeling a "moral deceit" — the right hand is barely modeled, and the texture of the canvas clearly visible beneath the paint emphasizes this two-dimensional quality. The cropping of the left shoulder, lower arm and chair shows the influence of Japanese prints. Gauguin wrote that he found in Arles "a combination of a colorful Puvis and Japanese art. The women here have elegant headdresses and a Greek beauty." Although Theo was perplexed as to why Japanese and Greek ideals of beauty were continually aimed at in Gauguin's aesthetic, the artist himself saw the art of the Japanese as "simple and composed."

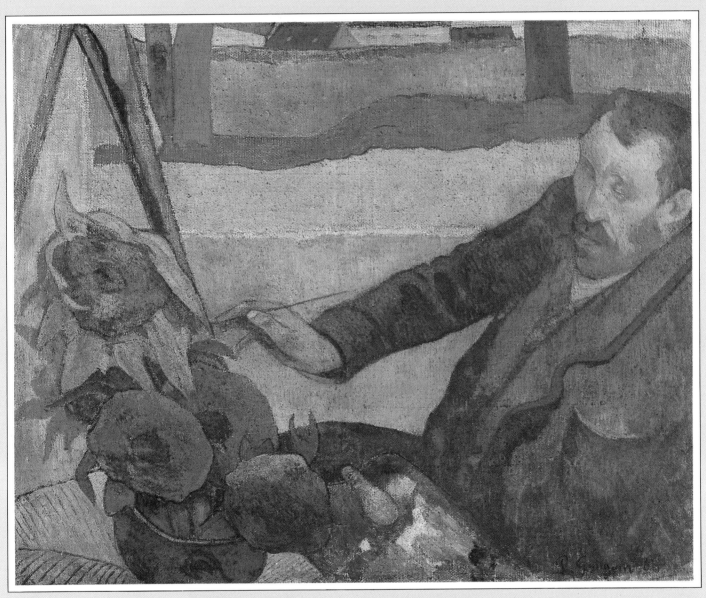

This portrait of Van Gogh at work on his favorite subject was painted during the couple of months the two artists worked together in the south of France. Originally they were both to have painted each other's portraits, but Van Gogh found Gauguin too intimidating a subject to work on. The composition balances two strong diagonals formed, on the right side, by the artist's arm, and on the left by the easel, sunflower petal and palette. The resulting void presents a curious, empty, abstract landscape of layered color, topped by a series of roofs between the blue-gray verticals of the flanking tree trunks. Naturalistic setting has been rejected for a decorative, abstracted background.

1

1 The treatment of the background shows how Gauguin rejected modeling in favor of an approach which flattens and does not "deceive" the viewer; he regarded modeling as dishonest. Shapes are outlined, as are the forms in Japanese prints, and the two-dimensional quality is further exaggerated by the way the paint does not conceal the texture of the canvas.

2 Van Gogh's beloved sunflowers give the color key to the painting, which everywhere echoes the yellows, rusts, browns, greens and blues of the flowers and vase. Van Gogh's blue-trimmed brown suit follows through the color harmonies, which are also reflected in the central abstracted landscape.

3 *Actual size detail* It is interesting to note the physical likeness to Gauguin himself in this portrait of Van Gogh. It was possibly not conscious, but Gauguin was evidently identifying himself with another painter, and an earlier letter to Van Gogh reveals that he saw artists as a separate group, oppressed by society.

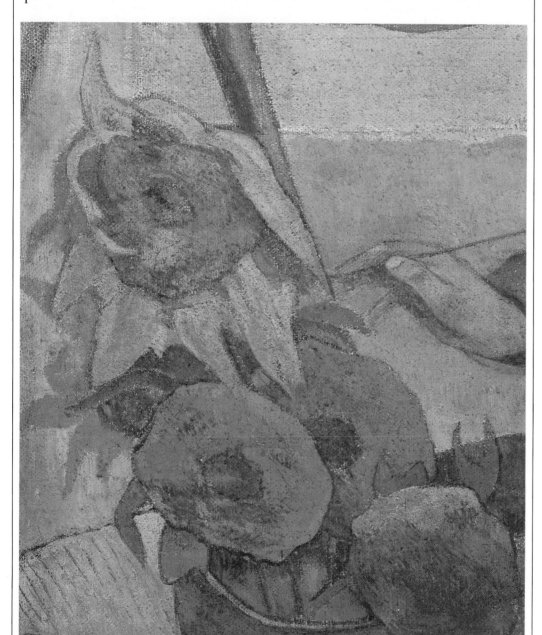

2

3 *Actual size detail*

THE YELLOW CHRIST

1889
36¾×29½in/92×73.5cm
Oil on canvas
Albright Knox Gallery, Buffalo

Inspired by the wayside shrines of Brittany with their religious images, Gauguin has modeled the figure of the crucified Christ on the wooden Christ in the church at Trémalo near Pont-Aven, where he returned in 1889 after the short period spent in Arles with Van Gogh. The painting clearly shows the way in which Gauguin abstracted images, intensified color and re-assembled concepts to form a personal interpretation of an idea.

Unlike the Trémalo crucifixion, which hangs on the church wall, Gauguin's has the setting of a field in Brittany, with Breton women mourning at the base of the cross. The color harmonies which he saw in the wooden figure, however, are used and accentuated in the painting; he had observed how the ivory-colored figure was thrown into yellow relief in the church by the bluish-white wall and blue arch beneath it.

Gauguin was deeply impressed by the "profoundly superstitious Catholicism" of the Breton peasants, and this painting is one of a series of religious pictures, which includes the *Self-portrait in front of The Yellow Christ*, *The Green Christ* and *Christ in the Garden of Olives*. In this work, as in *Vision After the Sermon* (see page 23), the scene is focused on the strength of the Breton women's faith, representing the power of an inner vision which brings to reality Christ's suffering. The simplicity of this true religious faith is rendered by angular perspective and simplified forms with their flat areas of unmodeled color and bold outline, while the pain that imbues the subject is echoed by the jangling color scheme of yellows and rusts. Gauguin sought a unity in his painting in which line, color and form all contributed to the mood he was attempting to express. Almost ten years later he was to write to his friend Daniel de Montfried in words which can be applied directly to this work: "Sometimes I hear people say: that arm is too long. Yes and no. No, principally, provided, as you elongate, you discard verisimilitude to reach out for mystery. That is never a bad thing. But of course all the work must reflect the same style, the same will. If Bouguereau made an arm too long, ah yes! What would be left him? For his vision, his artistic will only consists in that stupid precision which chains us to material reality …" (Bouguereau was a successful academic painter despised by the avant-garde.)

Gauguin was later to paint a self-portrait in front of a mirror image of this picture, associating himself with the figure of Christ, a man suffering and alone.

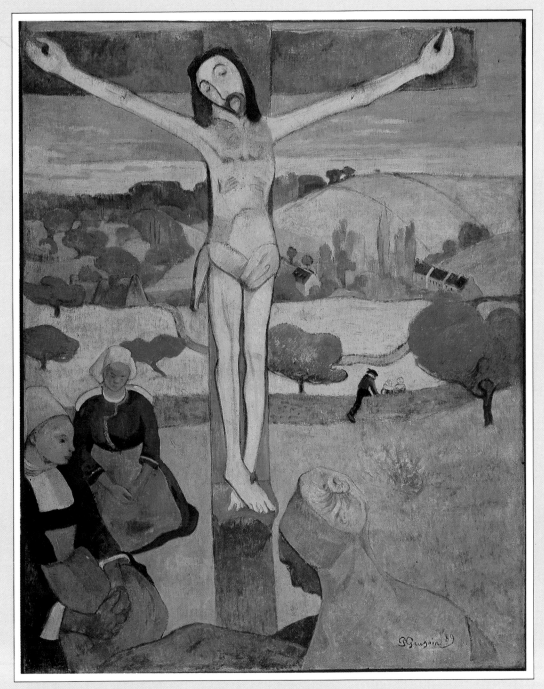

This painting is a masterpiece of Gauguin's Breton phase. The cross, placed slightly off-centre, dominates the entire painting, spanning both the height and breadth of the canvas. Balancing the strong verticals formed by the arms of Christ the picture is divided horizontally into foreground, middle ground and background. Color harmonies and technique are crude and primitive, reflecting the qualities Gauguin saw in Breton mysticism. It is a non-naturalistic work, combining imaginary forms suggested by actual images with a stylized landscape in a setting of the artist's own invention.

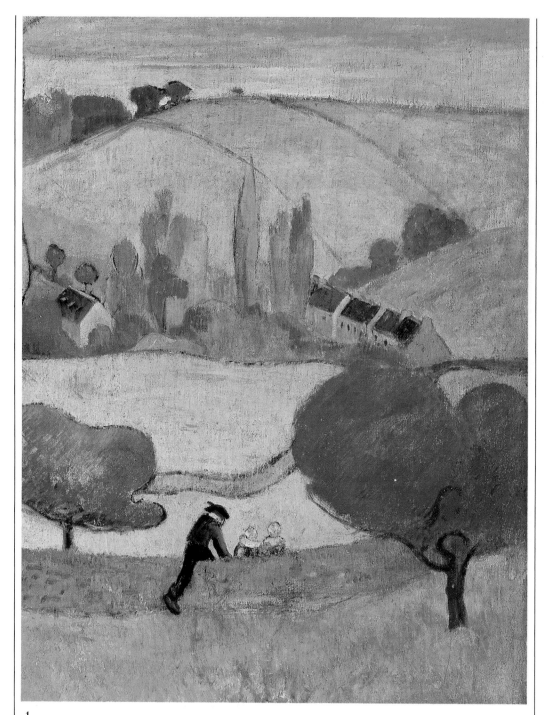

1 The figure of a sailor climbing over a stone wall provides incidental detail, giving a sense of the continuity of everday life in the face of tragedy, and thus enforcing the sense of man's isolation. Treated in non-naturalistic, heightened color, the background depicts the village of Pont-Aven beneath the hill of Sainte Marguerite. The blue contour lines of the landscape beneath the tree to the far right show it to be a later addition to balance the work.

2 *Actual size detail* Gauguin responded to the decorative properties of the traditional Breton peasant dress as he had to the Provençale costume at Arles. In the righthand foreground figure he has used color contrasts of blue and orange. The orange is not, however, applied as mixed color, but is created optically by hatching red pigment over yellow, unifying the background landscape of red over yellow.

1

2 Actual size detail

MANAO TUPAPAU:
THE SPIRIT OF THE DEAD KEEPS WATCH

1892

28¾×36¼in/73×92cm

Oil on canvas

Albright Knox Gallery, Buffalo

The strong religious faith of the Breton peasantry had made a strong impact on Gauguin, and in Tahiti he was similarly impressed by the beliefs and religious secrets of the islanders, which he became familiar with through a book called *Voyage to the Isles of the Great Ocean*, published in 1837 and written by a French consul to the South Sea Islands named Moerenhut. Passages of this book were later used by Gauguin in his own manuscript on the "Ancient Maori Cult," which itself was then incorporated in his work *Noa Noa*.

In this book, the title of which means "very fragrant," he states that his knowledge was received from his wife — meaning his thirteen-year old Tahitian companion Tehamana. This in fact seems unlikely, since women were excluded from knowledge of religious secrets, and these had, moreover, become more or less extinct by the time Gauguin arrived in Tahiti. On one occasion, however, he was struck by an incident which he believed demonstrated the "religious" fear still felt by the Tahitians. Returning home later than expected, he entered his hut to find Tehamana alone in the darkness (the light having gone out), lying face down on her bed, eyes open in terror and dread of the dark. The scene gave rise to this painting, one of his most important Tahitian works, which he frequently described at length. Writing to his wife Mette he said:

"I painted a nude of a young girl. In that position, a trifle can make it indecent. And yet I wanted her that way, the lines and the action interested me. A European girl would be embarrassed to be found in that position; the women here are not at all. I gave her face a somewhat frightened expression. This fright must be pretended, if not explained, and this is the character of the person — a Tahitian. These people by tradition are very much afraid of spirits of the dead. I had to explain her fears with a minimum of literary means,

unlike the way it was done in the past. To achieve this, the general harmony is somber, sad, frighteneing, sounding to the eye like a death knell: violet, dark blue, and orange yellow. I made the linen greenish yellow, first because the linen of these savages is different from ours (it is made of beaten bark), secondly because it produces and suggests artificial light (the Tahitian women never go to bed in the dark), and yet I did not want the effect of lamplight (it's common), third because the yellow which connects the orange-yellow and the blue completes the musical harmony. There are flowers in the background but, being imagined they must not be real: I made them resemble sparks. The Polynesians believe that the phosphorescences of the night are the spirits of the dead. They believe in them and dread them. Finally I made the ghost very simply like a small, harmless woman, because the girl can only see the spirit of the dead linked with the dead person, that is, a human being like herself."

As Gauguin explained in his *Intimate Journals*, the Tahitian language has few words but each one possesses many implications and he explained the two meanings of the painting's title, which means either "She thinks of the spirit of the dead" or "The spirit of the dead remembers her."

In Tahiti Gauguin's symbolism developed into a personal vocabulary of line, color, allusion, dream and memory in which he attempted to create an intensity of feeling which in the words of the German philosopher Schopenhauer, "aspired to the condition of music," but which also contained literary resonances. He concluded with a description of the painting's abstract qualities: "The musical part: undulating horizontal lines, harmonies of orange and blue brought together by yellows and purples...which are lighted by greenish sparks. The literary part: the spirit of a living soul united with the spirit of the dead. Day and Night."

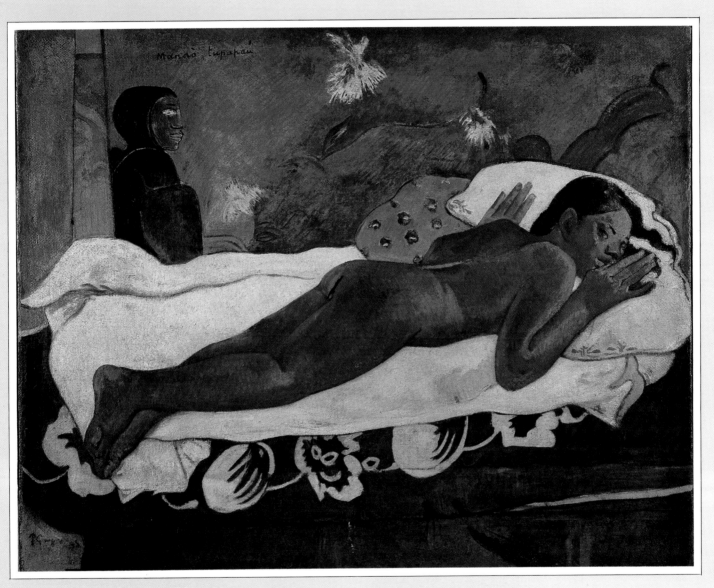

This is a consciously symbolic work. It is an attempt to convey an emotional mood — in this case terror — primarily by means of color. Like *Vision after the Sermon* (see page 23) this Tahitian work is separated into the imaginary and the real, in this case horizontally. This division is further emphasized by the different kinds of brushstroke and paint application; The flowers in the background, for example, are intentionally painted in a non-realistic manner, with the diagonally hatched mauve-blue strokes surrounding them kept free and delicate. Gauguin was attempting here to create a work of art with musical harmonies and mystical associations.

1 *Actual size detail* The face of Tehamana is modeled in green-brown, and the lips take up the pink of the cushion above her arm, while the whites of her eyes echo the greenish tinge of the bedding. Gauguin has used brushwork primarily to model the figure, which is highlighted in yellow ocher.

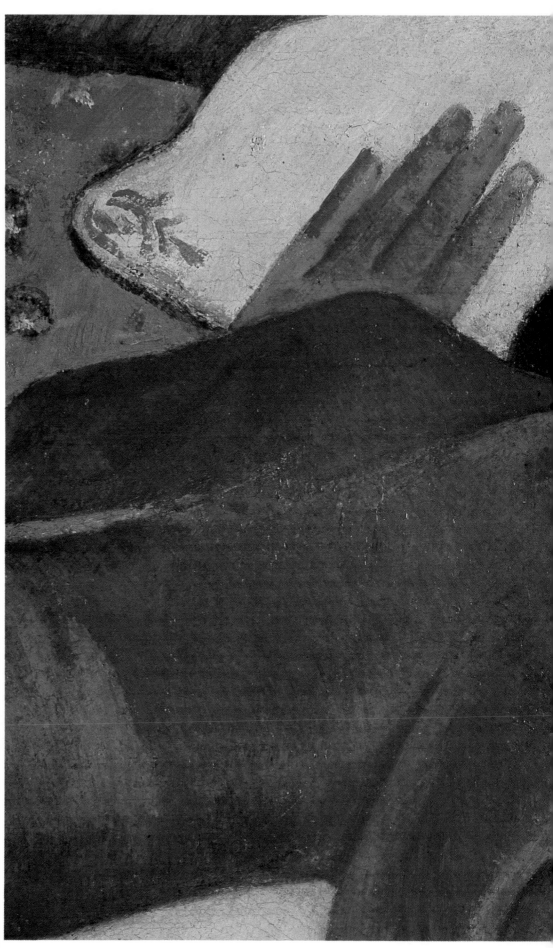

1 *Actual size detail*

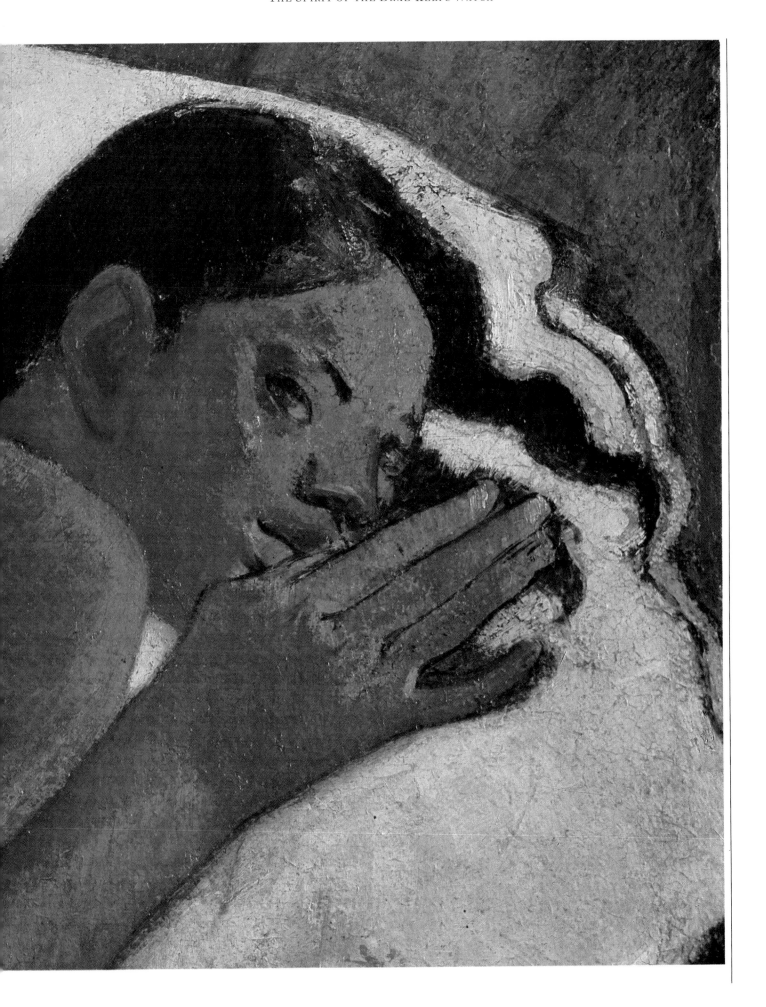

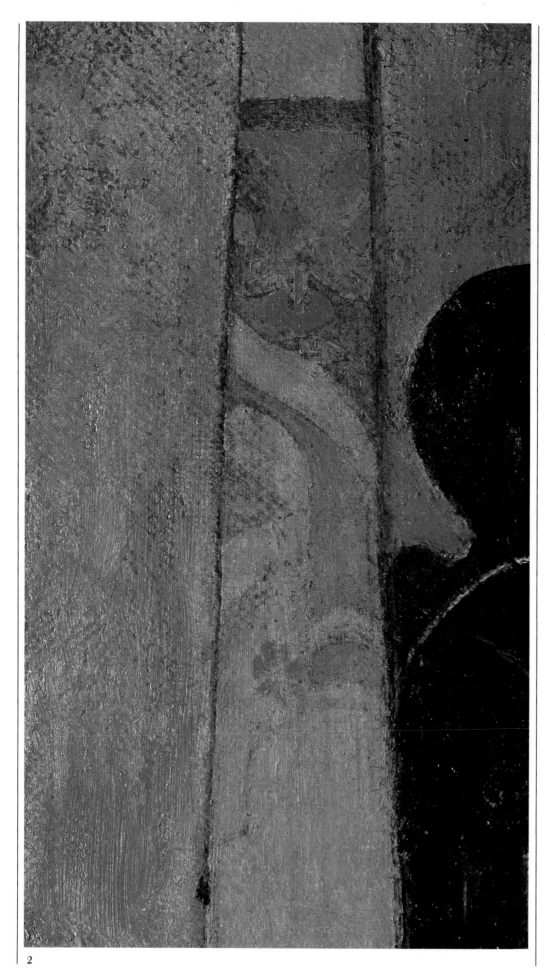

2

2 The totem pole has given Gauguin an opportunity to depict an abstract pattern. Color is thinly applied to the shapes of the pole and outlined in a thin blue glaze. Brushwork is not visible in this flattened pattern, which seems to incorporate the abstracted face of an idol and the back view of a man. This technique is reminiscent of his treatment of the headdress in *Vision after the Sermon* (see page 23).

3 The crude treatment of the ghost contrasts strongly with that of the recumbent living figure, and shows the influence of both Egyptian and native Tahitian art. The background is painted in diagonal strokes of color in the purple-blue range applied wet-in-wet, and creates a less easily apprehended setting, appropriate for the spiritual domain.

4 The flat print-like effect of the yellow flower on a dark blue background which represents the mattress intensifies the foreground area, which is actual, as opposed to the scene behind the bed, which is imaginary. It also forcefully creates a color scheme which Gauguin intended to be somber and frightening.

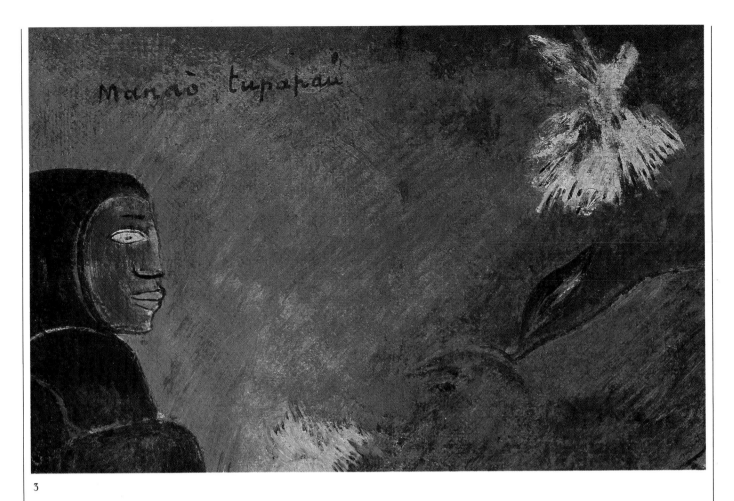

3

4

TA MATETE: THE MARKET

1892

29¼×36½in/73×91.5cm

Oil on canvas

Kunstmuseum, Basle

"Have before you the Persians, the Cambodians, and a little of the Egyptians" wrote Gauguin of a piece of sculpture. This canvas certainly reflects eastern influences, but most of all those of Egyptian art; Gauguin seems to have possessed photographs of the 18th-dynasty Theban wall paintings at the British Museum. The seated profile figure typical of Egyptian art greatly appealed to Gauguin because of the way the curvilinear shape could be used to depict the living form, thus obviating the need for foreshortening or modeling. "Line is a means of accentuating an idea," he wrote, and the Egyptian stylization of form, with its use of flat frontal planes, was seized on by him as a vehicle for expressing a mysterious and graceful series of gestures in a "savage" and "primitive" way.

Even so, traditional western perspective is not entirely rejected in the painting: the bench is placed on a slight diagonal slope, and figures appear to diminish both in psychological and coloristic terms as one moves from right to left. This may relate to a personal and complex symbolism which the title of the work itself reflects. Gauguin alluded to the ambiguity of the Tahitian language, and touched on its suggestive properties in *The Spirit of the Dead* (see page 35). The Tahitian title of this work has also been translated as "We Shall not Go to Market today" which radically alters our response to the calm frieze-like composition, offering a more complex interpretation. For instance, the suggestion of a dispute might be read in the hand gestures of the women, and the foreground figure on the extreme right appears in market clothes while the seated figures clothed in long robes do not. Her backward glance at the other women makes the viewer wonder about the possibility of a controversial exchange of words, and the techniques of involving the viewer in the picture is emphasized by the cropping of the foreground figure, thus implying a continuation of space which extends to the spectator.

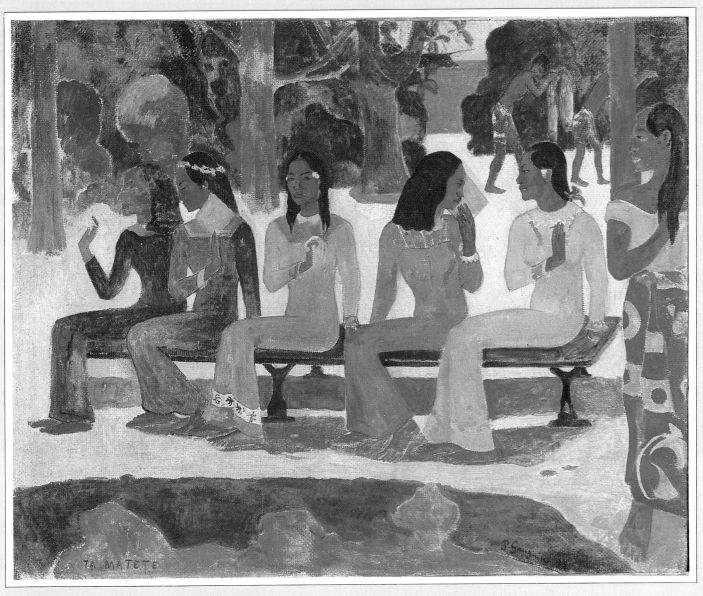

Left The two figures holding the fish on a pole between them are strongly reminiscent of Egyptian wallpaintings. The paint is applied very thinly, with the skin stiffly colored in brown and the *pareos* in blue with a strong outline of darker blue defining the forms.

One of Gauguin's most attractive and decorative works, this painting clearly shows the influence of Egyptian art. There is a clarity of color, form and action, and the construction of the picture balances a strong horizontal, created by the bench of seated figures, with vertical, almost musical intervals formed by the legs, backs, arms and raised hands of the sitters and the tree trunks behind them. Perhaps more than any other of his Tahitian works, this one evokes the golden age Gauguin was always seeking.

1 *Actual size detail* The stylization of the raised hands shows the influence of both Javanese and Egyptian art. The interchange between these two figures makes them the psychological focus of the work; their faces are, therefore, more tightly constructed than are those of the other women. There is also a brightness in color and a delicacy of detail which is not repeated in the other seated figures.

2 The figure on the far right is taken directly from Egyptian wallpaintings, and that next to her from a Javanese freize — Gauguin had photos of both. The "Egyptian" face is more crudely painted, with areas of canvas left visible as contour lines.

1 *Actual size detail*

2

NEVERMORE

1897
23¾×46¾in/59.5×117cm
Oil on canvas
Courtauld Institute Galleries, London

In a letter to Daniel de Montfried Gauguin wrote of his work: "I am trying to finish a canvas to send with the others ... I don't know if I am mistaken, but I believe that it's a good thing. I wanted, with a simple nude, to suggest a certain barbaric luxury of former times. The whole thing is suffused with color which is deliberately dark and sad; it's not silk or velvet, or fine lawn or gold which makes the richness of this painting, it is the hand of the artist ... It is man's imagination alone that has enriched this dwelling with his own fantasy."

The title, *Nevermore*, written in English at the top left of the painting is not, Gauguin explained "the raven of Edgar Poe, but the bird of the devil which is keeping watch. It is painted badly (I'm very nervous and work jerkily), it doesn't matter, I think it's a good canvas." Again we see Gauguin's stress on the importance of the "Idea" over all other considerations.

Nevermore is a consciously symbolic work in which the artist has attempted to create a poetic, literary and musical echo. The last word of Edgar Allen Poe's haunting refrain "Quoth the raven 'Nevermore,' brings to mind the words of the Symbolist poet Stephane Mallarmé, who maintained that the essence of a work of art lay in what was left out. Although Gauguin denied direct reference to Poe's poem, the work clearly carries overtones of Poe's lament for a loss, not easily put into words. Poe's poem was one of those read aloud at Gauguin's farewell banquet at the Café Voltaire preceding his first trip to Tahiti.

Translated both by Baudelaire and Mallarmé, Poe's work was of enormous influence on the French Symbolists in the last two decades of the century. Gauguin admired the work of all three men, being particularly attracted to the importance placed on the imagination and instinct over realism. "As in 'The Purloined Letter' [a short story] of Edgar Poe," Gauguin wrote in his *Intimate Journals*, "our modern intelligence, lost as it is in the details of analysis, cannot perceive what is too simple and too visible." The words apply directly to the major part of Gauguin's work.

The direct inspiration for the earlier painting, *The Spirit of the Dead*, done on his first trip to Tahiti, had come from Tahitian legend, which is also a theme in *Nevermore*. Fascinated by island lore, he recorded in his manuscript *Noa Noa* something of a legend told to him by his young companion Tehamana (who he called Tehura in his literary work). There he tells of finding Tehura rigid with fear as she imagined the "tupapas", the spirits of the dead, walking in the darkness, crying out between her sobs, "Never, never leave me alone like this without a light."

Gauguin's own description of *The Spirit of the Dead* reveals that he also considered the role of music important in his painting. It was part of the "synthetist" experience to blend together all art forms to produce a sensation which approximated to the way in which music conveys a mood. It was the aim of all Symbolist art to "aspire to the condition of music." Interestingly, the painting was bought by a musician — the composer Delius purchased it for 500 francs the year after it was painted.

Gauguin's leadership of the Symbolist art movement resulted largely from an article by the influential art critic Albert Aurier, in which he said: "Paul Gauguin seems to me to be the initiator of a new art, not in the course of history, but at least in our time ... The normal and final goal of painting, as of all arts, cannot be the direct presentation of objects. Its ultimate goal is to express Ideas by translating them into a special language. To the eyes of the artist ... objects are valueless merely as objects. They can only appear to him as signs. They are the letters of an immense alphabet which only the man of genius can combine into words."

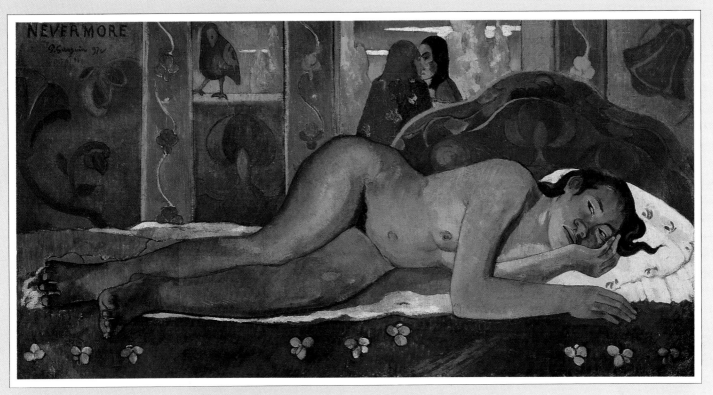

Like *The Spirit of the Dead* (see page 35) this work depicts a naked recumbent female in a setting which combines the real and the imagined. Gauguin found the physique of "Maori" women more aesthetically pleasing than that of the European female, whose "enormous thighs" and turned-in knees he scorned.

"In the Oriental and especially the Maori women," he remarked, "the leg from hip to foot offers a pretty, straight line. The thigh is heavy but not wide, which makes it round and avoids that spreading which gives to so many women of our country the appearance of a pair of tongs."

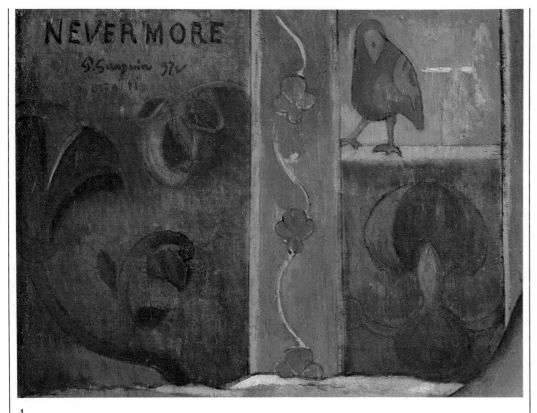

1

1 As in many of Gauguin's works the title is painted onto the canvas as an integral part of the painting, contributing a "literary" association to the painted poem. Beneath the signature flow the curves of two imaginary exotic flowers, painted wet-in-wet, and outlined delicately in a thin blue glaze. The exotic bird, painted in blue, green and lilac next to an abstracted landscape of muted red, lilac and cream, forms a decorative detail in a highly decorative work. Panels of blue flowers on a lilac background flank the bird and the curious vessel beneath, which is reminiscent of Gauguin's own sculpture.

2 The bedding around the feet shows the patterning effect of vertical brushwork, scumbling and muted color, which contrasts strongly with the flat evenly-painted area of bright red above the right foot. Shadow is almost entirely rejected, and by extending the white of the sheet beyond the right toes the artist has formed a highlight; an ironic inversion of what the western eye is trained to expect.

3 *Actual size detail* The face is modeled in broad sweeps of dark flesh tones, shadowed in green. Features are darkly outlined in a non-naturalistic manner. The contours of the naked from are also drawn in Prussian blue, which flattens the form and produces a less naturalistic and more decorative approach.

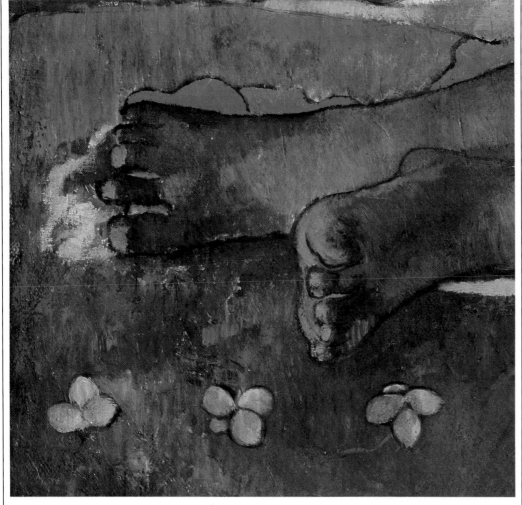

2

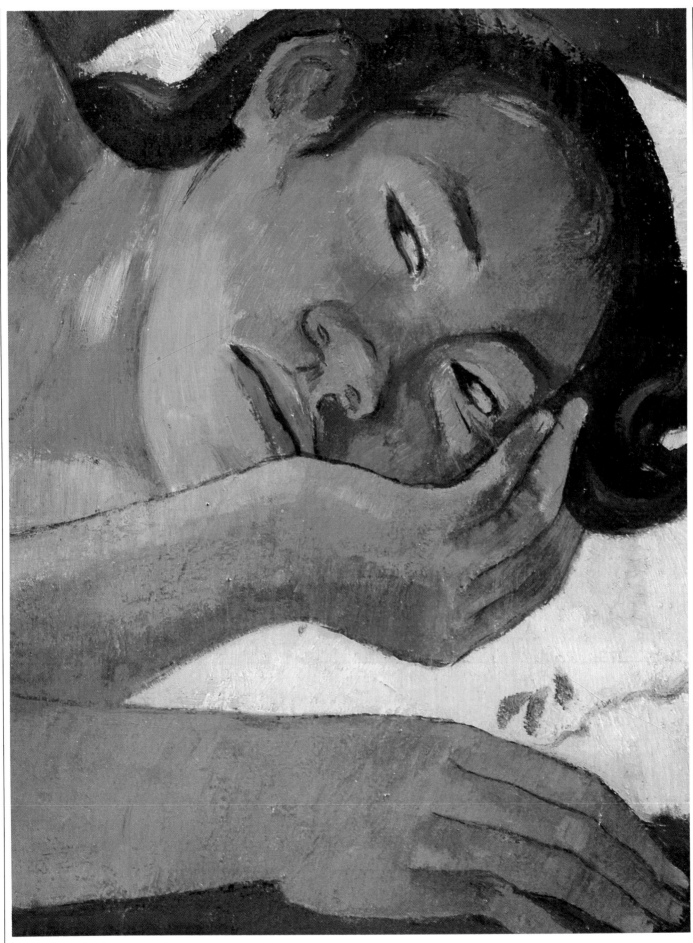

3 *Actual size detail*

WHERE DO WE COME FROM? WHAT ARE WE?
WHERE ARE WE GOING TO?

1897

55½ × 149¾ in / 139 × 374.5 cm

Oil on rough canvas

Boston Museum of Fine Arts

After years of hardship in Tahiti, suffering dreadfully from eczema, Gauguin prepared to commit suicide after painting his most important work. "Before I died," he wrote, "I wished to paint a large canvas that I had in mind, and I worked day and night that whole month in an incredible fever."

After the painting was finished Gauguin took a huge dose of the arsenic he had hoarded to treat his eczema, but instead of killing him it caused a night of severe and painful vomiting. He survived to leave detailed accounts of this painting, and in February 1898 he wrote to Daniel de Montfried: "To be sure it is not done like a Puvis de Chavannes, sketch after nature, preparing cartoon etc. It's all done straight from the brush on sackcloth full of knots and wrinkles, so the appearance is terribly rough."

"It is a canvas 4 meters 50 in width, by one meter 70 in height. The two upper corners are chrome yellow, with an inscription on the left and my name on the right, like a fresco whose corners are spoiled with age, and which is appliquéd upon a golden wall. To the right at the lower end, a sleeping child and three crouching women. Two figures dressed in purple confide their thoughts to one another. An enormous crouching figure, out of all proportion, and intentionally so, raises its arms and stares in astonishment upon these two, who dare to think of their destiny. A figure in the center is picking fruit. Two cats near a child. A white goat. An idol, its arms mysteriously raised in a sort of rhythm, seems to indicate the Beyond. Then lastly an old woman nearing death appears to accept everything, to resign herself to her thoughts. She completes the story! At her feet a strange white bird, holding a lizard in its claws, represents the futility of words. It is all on the bank of a river in the woods. In the background the ocean, then the coloring of the landscape is constant, either blue or Veronese green. The naked figures stand out in bold orange ... So I

have finished a philosophical work on a theme comparable to that of the Gospel. I think it is good."

Gauguin has tried in this word picture to convey, but not interpret, the symbolism of this painting, which had been met with incomprehension. André Fontainas, the critic of *Mercure* (which Gauguin read in Tahiti) had compared Gauguin unfavorably with Puvis de Chavannes, which caused Gauguin to write to his friend Charles Morice in 1901: "Why, before a painting, does a critic find it necessary to make a comparison with the too often expressed ideas of other artists? Not finding that which he believes ought to be there, he fails to understand and is not moved. Emotion first. Understanding follows.

"Puvis ... knew well how to express his ideas ... Puvis explains his idea, but does not paint it. He is a Greek, while I am a savage. Puvis calls a painting 'Purity' ... he paints a young virgin with a lily in her hand — an obvious symbol — and is understood. Gauguin, with the title 'Purity' paints a landscape with limpid waters, unsoiled by the hand of man ... there is a world of difference between Puvis and me."

Gauguin felt impelled to spell out the painting's symbolism as follows:

In the large painting:-

Where are we going?

An old woman nearing death

An exotic stupid bird

What are we?

Daily existence

The man of instinct wonders what all this means

Where do we come from?

The brook

A child

Communal life

The strange bird concludes the poem — an inferior being contrasted with an intelligent one, which is the answer sought in the title.

"Behind a tree, two sinister figures,

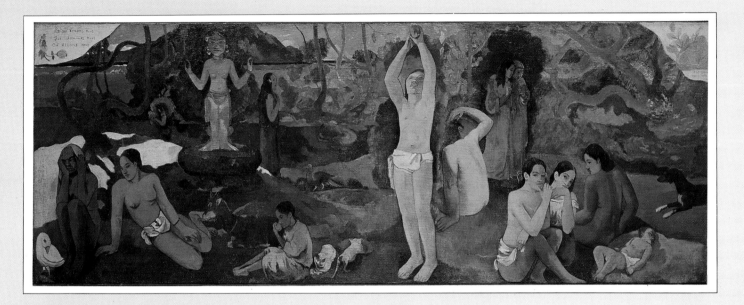

wrapped in gloomy clothing, inject their note of sorrow, near the tree of science, caused by this name science, as compared with the simple beings in a virgin nature, a paradise of human conception, giving themselves up to the joys of living."

Although this seems to proffer an explanation it does not explain the derivation of Gauguin's symbolism.

To Fontainas himself Gauguin wrote in 1899: "If my dream is not communicated it contains no allegory. It is a musical poem; it does not require a libretto. 'The essential work of art,' said Mallarmé, 'consists precisely of that which is not expressed: there result lines, without color or words, which are not materially expressed.' Mallarmé understands my Tahitian paintings [remarking]: 'It is extraordinary that one can put so much mystery into so much splendor.'

"... Coming back to the panel: The idol is not a literary explanation, but a statue ... It all took form in my dream in front of my hut. There all nature dominates the primitive soul; it is the consolation of our suffering, full of the vague and the incomprehensible in the presence of our origin and our future."

Intended as his last, most important work before ending his life, this painting is one of Gauguin's most significant. He has chosen a frieze-like construction which contains no single focus but depicts separate references to the journey of human life. The continuity of action offered by the frieze form is well suited to this concept, and also suggests both an origin and an end which continues beyond the painting itself. It is a translation of a dream on the nature of existence into a "musical poem" without explanatory symbols whose literalism would destroy the essential form. It is painted directly onto a rough sackcloth without preparatory sketches, which Gauguin felt to be the best means of truthfully conveying his idea.

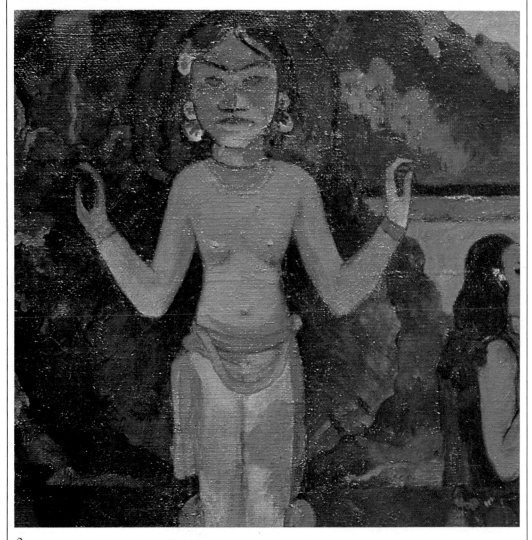

1

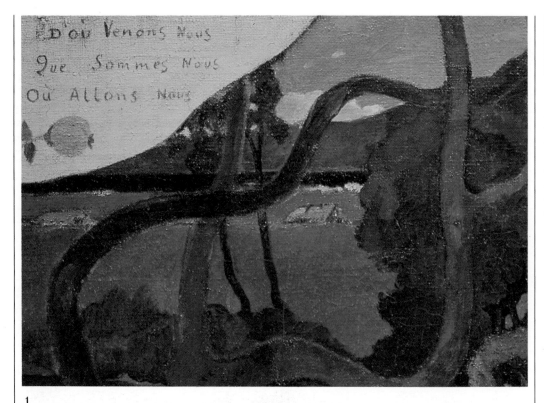

2

1 The title of the work appears in French on a chrome yellow background, and was intended to resemble the corners of an ancient fresco. To the left of the title an open flower and one in bud provide a decorative curve on the otherwise flat area of color.

2 Painted entirely in monochromatic blues, the figure of the idol shows Gauguin's debt to Eastern art. Fascinated by the cult of the ancient Tahitian gods, he has reworked an emblem of an extinct culture into a work whose theme he saw as comparable to that of the Gospel. The strong vertical of the figure in profile on the right is set against a landscape which comprises the curving trees of a woodland riverbank, beyond which lies the ocean below a strong horizontal of dark blue.

3 *Actual size detail* The old woman on the extreme left of the canvas completes the story of human life begun with the baby on the right. She sits in quiet resignation, accepting the inevitable approach of death.

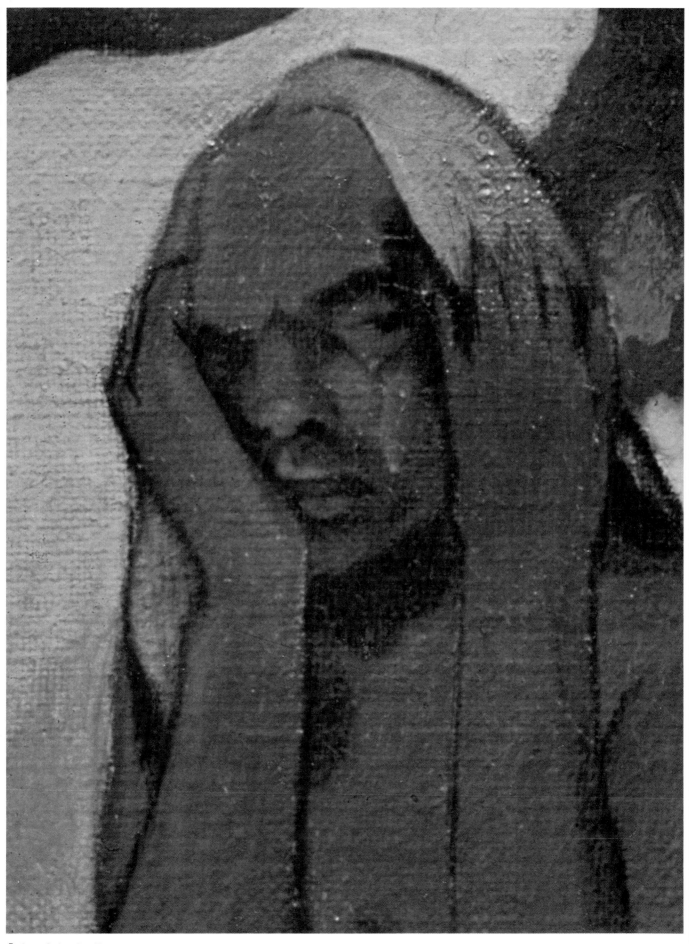

3 *Actual size detail*

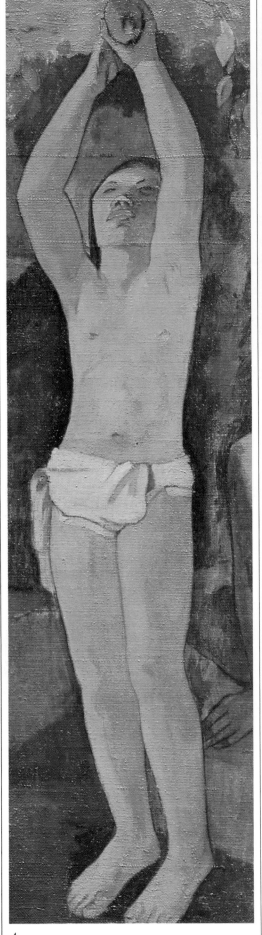

4

5

6

4 More than any other element in the painting this semi-clothed man is the focal point of the work. Not only does he span the whole height of the painting, breaking it into two sections, he also indicates, in reaching for fruit from a tree out of our vision, an extension of space above the boundaries of the picture, which has psychological relevance to a work with the theme of the nature of existence. The weave of the sackcloth support is clear in three separate horizontal lines which run across much of the picture surface but which are most clearly visible over the face of this standing figure.

5 The brilliance of this small, brightly colored exotic bird stands out against a background of red and green, in contrast to the monochrome treatment of the nearby idol and pedestal.

6 The white bird holding a lizard sits at the feet of the old woman at the extreme left of the painting, and both were seen by Gauguin as representing the futility of words and the acceptance of death. In a letter of 1899 he said "Do you see how useless it is for me to understand the value of words...With all the sincerity possible, I have tried...to translate my dream without the aid of literary devices."

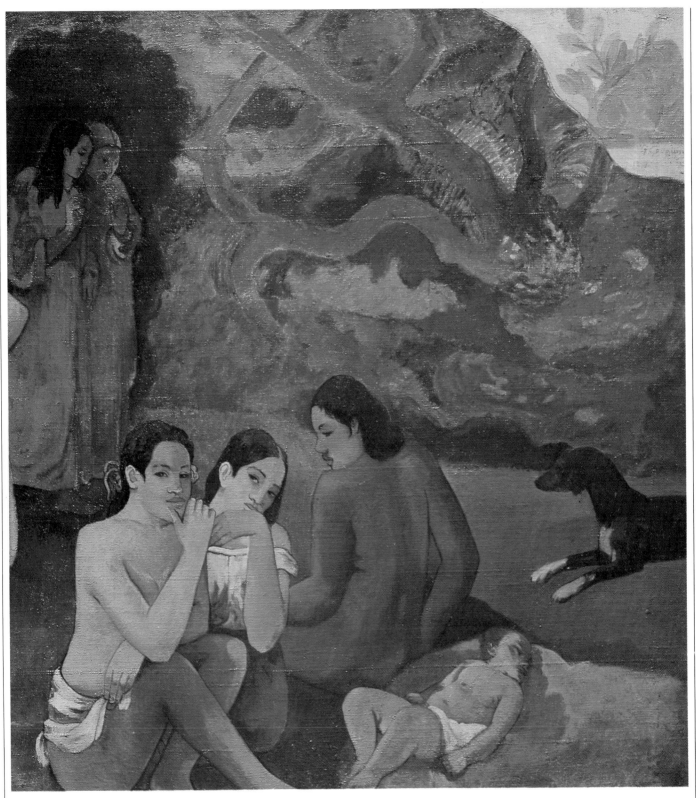

7

7 Although Gauguin painted this quickly and "jerkily" due to pains and illness, the two foreground figures are remarkably clearly executed in flat areas of yellow ocher, shadowed in green. The flat treatment of the muted red background on which the dog sits contrasts with the broken brushwork and dabs of varicolored paint above.

THE WHITE HORSE

1898

56×36½in/140×91cm

Oil on rough canvas

Musée d'Orsay, Paris

This picture shows a return from the horizontal frieze-like arrangement Gauguin had been using to a vertical form, with spatial recession suggested by the way figures are placed one above the other. It unites features of the art of the east, especially that of Japan, with that of the west, fusing together Japan and Greece in a blend Gauguin had often sought. His earlier Impressionist treatment of a similar theme, the *Still life with Horse's Head* of 1885, combines decorative Japanese fans and a puppet with a Classical Greek marble horse's head, derived from one of those on the Parthenon pediment. Gauguin possessed several photographs of Greek subjects, including those of the Parthenon frieze and pediment in the British Museum, which served as models in his paintings.

The White Horse shows a more subtle blending of the two traditions, the influence of Japanese prints being evident in the vertical, asymmetrical arrangement of the canvas, the flat areas of unbroken color and the decorative overlay effect produced by the curvilinear patterning of the branches. The spirit of traditional western classicism is embodied in the emblematic use of the white horse itself; it is still basically the Parthenon horse, but here Gauguin has inverted the head to create an image of a young animal drinking from a brook.

Traditional western techniques are also much more evident in this work than in those done in the preceding dozen years, and we see a return to naturalism in the depiction of the horse itself. This is modeled in tones, unlike the earlier flat-pattern paintings, with the tones taking up the reflections of water and foliage. The image of the horse, whose physical beauty and strength embodies the classical ethos, was frequently employed by Degas, whom Gauguin greatly admired for having "a contempt for art theories," and "no interest in technique." Acknowledging his own debt to the master he asserted that, "people are always borrowing from Degas."

The powerful image presented in this work had an influence on a subsequent generation of artists, particularly the German Expressionists. Although Gauguin himself left no record of this particular work, his personal symbolism, recorded in letters to Charles Morice, Daniel de Montfried, André Fontainas, and his wife, suggest that the image was intended as one of purity, solitude, nobility and power. The white horse stands alone, refreshing itself in the shallow water — an elemental source of life and sustenance often symbolizing purity. It is tempting to interpret the image in terms of the artist himself — the solitary, wild but pure beast over whom no one has control, a feature emphasized by the presence of the two other horses with their naked riders. Such an interpretation is given validity by Gauguin's quotation in his *Intimate Journals* of Degas' remark about him being like the lone wolf — hungry but free.

The painting also presents an idyll, a pastorale where man and beast co-exist in harmony with nature. The harmony is stressed by the stream and waterfall running through the center of the painting and the trees, with their branches encircling the free and naked riders and their mounts. A white lily in the foreground, leading the eye into the body of the canvas, typifies, with its traditional association of purity, the symbolism of the work, which Gauguin's personal vocabulary enlarges on.

Painted at speed with decisive brushstrokes and the occasional use of a palette knife, *The White Horse* is one of Gauguin's most harmonious works, communicating, by symbolism and allusion, color and line, the poetry he sought to convey.

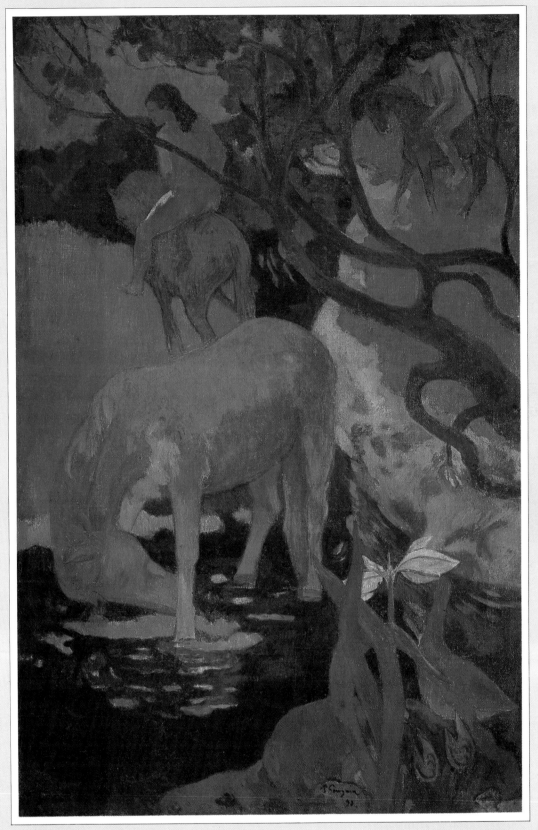

As in *Vision after the Sermon* (see page 23) the picture plane of *The White Horse* is diagonally bisected. Here it is not a single bough which cuts across the surface of the canvas but a series of curvilinear branches overlaying a pattern. This picture shows the diversity of Gauguin's approach to brushwork and modeling, which ranges from the flat, print-like effect on the upper right to the crude hatching of the red horse, the vertical brushwork of its surrounding, and the relatively high degree of color modeling of the white horse itself.

1

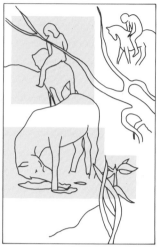

2

1 Here, in direct contrast to the white horse, Gauguin has hatched green-brown pigment over red. Foreshortening and anatomical precision have been subordinated to decorative effect. The roughness of the canvas he used to paint on is evident in the slightly raised horizontal texturing which runs through the lower back of the rider and is most clearly seen in the blue area to the right.

2 The horse's head, derived from photographs of the Elgin marbles, is crudely modeled in green, its features outlined in dark green instead of the dark blue which is used to silhouette the two other horses. The reflections are painted both as contained areas of pure color and — below the horse's foot — wet-in-wet. The underbelly of the horse shows a greater degree of modeling than Gauguin normally used, though the essential crudeness has been retained in the dark green contour of the belly.

3 *Actual size detail* The green-white tones of the lily reflect those of the white horse. Paint is applied fairly stiffly in contrast to the freer wet-in-wet and wet-in-dry treatment of the area immediately above.

3 *Actual size detail*

THE CALL

1902
51¼×35½in/130×90cm
Oil on canvas
Cleveland Museum of Art

In 1901 Gauguin left Tahiti for Hiva-Oa in the Marquesas Islands in the further hope of finding unspoilt land. Frequent bouts of illness had made him weak, yet he continued to paint and to agitate on behalf of the natives against the French colonial authorities, for which he was later imprisoned. Despite the incursion of French bureaucracy which threatened the native way of life Gauguin found his new habitat congenial, writing to de Montfried, "Here in my isolation ... poetry wells up by itself, and one has only to permit oneself to fall into recovery as one paints in order to suggest it."

This work recreates the qualities Gauguin believed necessary in a work of art. "Seek for harmony and not contrast, for what accords, not what clashes...Go from dark to light, from light to dark. The eye seeks to refresh itself through your work; give it food for enjoyment, not dejection...Let everything about you breathe the calm and peace of the soul. Avoid motion in a pose. Each of your figures ought to be in a static position."

"The great error is in the Greek" observed Gauguin, yet he recognized its beauty while decrying the way in which its "perfection" had come to stifle post-Renaissance art by its stress on physical accuracy. Gauguin also recognized that one was bound by one's heritage, however hard one might try to reject it. The gesticulating figure on the right was drawn from the Parthenon frieze. Through his reading of Telemachus, around this time, Gauguin discovered a similarity between ancient Greece and Tahiti. The evocation of a golden age, and the simple handling of the elements in the painting also calls to mind the work of Puvis de Chavannes, with whom Gauguin was so often compared, and whose work, in reproduction, decorated Gauguin's primitive hut.

The Call is an expression of Gauguin's response to Tahiti as a tropical paradise. "In order to explain my Tahitian art, since it is held to be incomprehensible: as I want to suggest an exuberant and wild nature and a tropical sun which sets on fire everything around it, I have given my figures an appropriate frame. It really is open-air life, although intimate; in the thickets and the shaded brooks, those whispering women in an immense palace decorated by nature itself with all the riches Tahiti holds. Hence these fabulous colors and this fiery yet softened and silent air."

The painting is an attempt to unite real landscape, borrowed classical form and mysterious subject matter. The work is non-literary, an evocation of everyday island life made dreamlike and magical. There is less use of ornamentation than in other of Gauguin's paintings, the flat areas of color producing a two-dimensional pattern-like effect within which small brushstrokes indicate texture and model form. The color harmonies of lavender, violets, purples and blue are softer and lighter than in his earlier work, and sharp contrasts are avoided.

Calm and grandeur are evoked not only by the color range but also by the balance of horizontal and vertical which rest in the fulcrum of the crouching woman. This painting reflects a positive expression of the artist's attitude toward nature, with which his letters and paintings alike both show him to be in harmony. Yet the painting was executed in the face of the encroaching western civilization which menaced the island life Gauguin had long hoped to find. The actual depiction of the native life and landscape of the Marquesas is not so much a record of a threatened paradise as a vision of a golden age Gauguin had sought from infancy.

This painting, among Gauguin's later works, indicates a new direction toward a lighter, brighter palette, prefiguring the work of Matisse and the Fauves. Color takes on a luminous clarity, and brushwork is again visible. The vertical series of brushstrokes show a return to the tapestry-like effect Gauguin was using before the development of his mature style which favored the flat application of even color intensified by a dark line. This painting is a decorative work which achieves a calm gravity through the static quality of the figures.

1

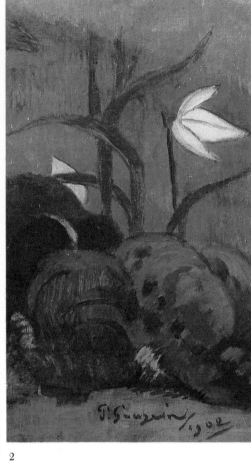

2

1 The background area, with its use of brushwork to structure nature into planes, is reminiscent of Cézanne. Gauguin has used the same colors as in *Where Do We Come From?* — blue and Veronese green, but here they are applied with long, vertical brushstrokes.

2 The lily is painted with a fairly stiff application of white, outlined in blue, and overlaid with an orange stroke painted wet on dry. The leaves are also treated with a stiffish application of paint. The vegetation underlying the lily is, by contrast, a muted background of varicolored vertical strokes.

3 The back of this seated figure shows a greater degree of modeling than Gauguin had employed in previous paintings. The area beneath the figure shows a color harmony of startling brightness, achieved by scumbling lighter, mixed colors over a light red background.

4 The surrounding landscape clearly shows the vertical brushstrokes Gauguin used throughout the painting. The luminescence of the pinky-mauve dress is achieved by laying down thinned pigment in close color harmonies.

5 *Actual size detail* Here Gauguin has altered his technique, using a lighter touch and handling of paint to convey the delicacy of the wild flowers.

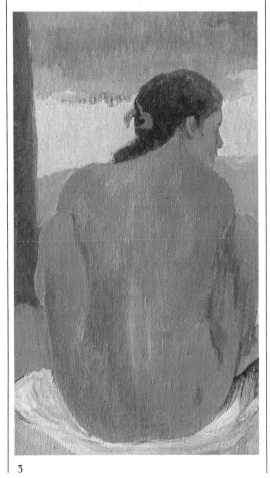

3

4

5 *Actual size detail*

INDEX

PHOTOGRAPHIC CREDITS

The photographs in this book were provided by the following:
Bridgeman Art Library, London 24-25; Courtauld Institute
Galleries, London 31-33; Mike Fear, London 11; Hubert Josse, Paris
7, 9, 19-21, 27-29, 35-37, 39-42, 45-47, 53-55, 57-60; National
Gallery, London 23; Photo Routhieu, Paris 6; Visual Arts Library,
London 8, 10, 11, 14, 15, 43 top and bottom,
49-51, 61 top and bottom.